IMAGE
of Amer

D0862847

# NEW ORLEANS
## THE CANAL
## STREETCAR LINE

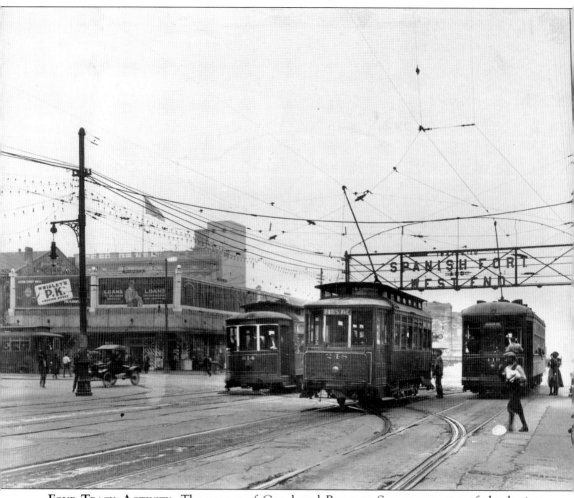

**FOUR-TRACK ACTIVITY.** The corner of Canal and Rampart Streets was one of the busiest for streetcars in New Orleans. This Teunisson photo from around 1915 shows three different types of cars on the four tracks that ran the length of Canal in the Central Business District. On the left is one of the comfortable "Palace" cars, heading outbound toward the cemeteries. In the center is a single-truck car running on the Paris Avenue line, heading inbound towards the Mississippi River. On the right-hand track, also heading toward the river, is a 400-series, Perley Thomas–designed arch roof streetcar. The 400-series were the first cars designed by Mr. Thomas that ran on New Orleans's streets, followed by the more well-known 800- and 900-series. This car is running on the Jackson line. (Courtesy Louisiana State Museum.)

IMAGES
*of America*

# NEW ORLEANS
## THE CANAL
## STREETCAR LINE

Edward J. Branley

ARCADIA
PUBLISHING

Published by Arcadia Publishing
Charleston SC, Chicago IL, Portsmouth NH, San Francisco CA

Printed in the United States of America

Library of Congress Catalog Card Number: 2003114005

For all general information contact Arcadia Publishing at:
Telephone 843-853-2070
Fax 843-853-0044
E-mail sales@arcadiapublishing.com
For customer service and orders:
Toll-Free 1-888-313-2665

Visit us on the Internet at www.arcadiapublishing.com

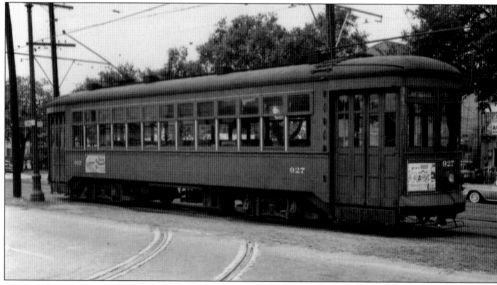

**NEAR CANAL STATION.** Perley Thomas car 927 operated lakebound on the third track that ran from White to Gayoso Streets. This siding track allowed cars to enter/exit Canal Station without interfering with operations on the Canal line. Car 927 appears to be preparing to enter the barn after a run on Canal. The car is moving in the outbound direction, toward the cemeteries. The Perley Thomas cars are "double-ended," meaning the motorman changes directions by pulling down the active trolley pole and releasing the one on the other end of the car. He then moves to the end of the car opposite the active pole and operates the controls from there. This particular car is in a bit of a run-down condition, in need of a paint job on the front end. New Orleans Public Service, Inc. (NOPSI) was a for-profit entity, so the look of the cars was not as important as their ability to run. (Courtesy of New Orleans Public Library.)

# CONTENTS

# ACKNOWLEDGMENTS

A number of people contributed to this book becoming reality. All my love to my wife Helen for putting up with this project, and to my sons Justin and Kevin for coming along on streetcar rides. A huge bundle of thanks to Mr. Wayne Everard, archivist in the Louisiana Division of the New Orleans Public Library, for his assistance. Also to Mr. John C. Kelly of the Louisiana and Special Collections Department, Earl K. Long Library, University of New Orleans, and Mr. Nathaniel Heller, assistant registrar, Louisiana State Museum, for their assistance in obtaining photos from their collections. Thanks to Dr. H. George Friedman Jr. for fact-checking assistance and general inspiration, and to Mr. Erby Aucoin III for giving me permission to use his dad's photo. Special thanks to Mr. Elmer Von Dullen, Ms. Marsha Hopper, and Mr. James Baker of the New Orleans Regional Transit Authority, for all their assistance. Thanks to Jenifer Hill Akers for checking my grammar, my friends on LiveJournal and the various trolley mailing lists on the Internet for their support, and the CC's Coffee Houses in Metairie and Kenner for providing me with a good writing environment when I needed to get away from my desk.

This book is dedicated to my English teachers from Brother Martin High School and my professors from the History Department and the College of Education of the University of New Orleans.

# INTRODUCTION

It's a paradox.

Streetcars and Canal Street, that is. Maybe it's because the St. Charles Avenue line has been operating continuously since 1834. Maybe it's *Streetcar Named Desire*. Maybe it's because the Canal line vanished for almost 40 years. Whatever the reason why people don't connect Canal Street with our streetcars, the fact is that New Orleans's streetcars always have been about getting people to Canal.

Canal Street has been the primary traffic artery for downtown New Orleans and the French Quarter for over 150 years. Its unusual width (170 feet) and its position as the boundary between the old section of the city with the newer (and expanding) business district attracted a wide variety of businesses, stores, and shops. In addition to commercial activity, Canal Street became the hub for transportation in the city. Major railroads terminated either on Canal or within blocks of the street. The ferry connecting the main part of the city on the east bank of the Mississippi River with the western side was at the foot of Canal Street. In short, if you had to get someplace, your trip most likely involved going to Canal Street.

Transporting people downtown was an entrepreneurial opportunity throughout the 19th century. Private companies would identify the need for various neighborhoods to have a connection to downtown and would establish omnibus or street rail (using horse- and mule-drawn cars) to meet the need. While this was good from the perspective of free enterprise, the myriad of street railway operators in the city made for a complex maze of tracks and routes. Electrification in the 1890s changed that, forcing the small operators to merge with larger companies. By 1905, New Orleans had 191 miles of streetcar track, and Canal Street was hub, with almost every operating line using Canal as an inbound terminus. From Rampart Street to South Peters (by the river), streetcars would turn onto Canal from connecting streets, travel a block or two on the main artery, then turn away from Canal to return to the neighborhoods from which they originated.

It's all about getting to Canal.

Then there is the Canal Street line itself. Originally operated by the New Orleans City Railroad Company, the line opened on June 15, 1861. The line ran from the car barn on White Street to St. Charles Avenue. On August 24, 1861, the line was extended to run to the end of Canal Street, where there is a large concentration of cemeteries. This extension enabled anyone in the city to get to the cemeteries as well as the Mid-City neighborhoods along the way. The line's animal power was replaced with electric cars on August 1, 1894.

The period from the 1890s to the 1930s marked a time where streetcars were extremely popular across the United States. New Orleans was no exception to this, with track mileage reaching a peak of 225 miles in 1922. Street railway companies acquired and operated a number of different types of vehicles during this period, starting with the small, single-truck cars, then using double-truck semi-convertibles on busier lines.

The uncoordinated growth of electric railways in New Orleans reached a point by the 1920s that an overall plan had to be developed. A single operating company, New Orleans Public Service, Inc. (NOPSI), was formed. The city gave NOPSI control of New Orleans's electricity, gas, and transit services in 1922, and almost immediately the company began to consolidate street railway routes and equipment. The elegant "Palace" cars, which ran the Canal Belt line, were phased out in favor of the new arch roof cars from the Perley A. Thomas Company. By 1935, the arch roof cars dominated the city-wide streetcar fleet and were regular fixtures on Canal Street.

The rise of the streetcar so closely identified with New Orleans came at a time when streetcars overall were in decline. The economic growth of the 1920s evaporated with the Great Depression, and NOPSI saw its future in buses, not streetcars. Neighborhood lines were converted to buses, and by 1940, the number of track miles had dropped from a high of 225 to 109. World War II placed an external hold on the decline of streetcars, in the form of the Office of Defense Transportation's freeze on abandoning street railways. Abandonment picked up in 1946 where it left off before the war, and by 1953, there were only two streetcar lines left in New Orleans: St. Charles and Canal. It looked like the citizens of "The City That Care Forgot" had forgotten to care about their street railways.

NOPSI's efforts to eliminate the last two streetcar lines in the city grew stronger in the late 1950s. The primary target of these efforts was the Canal line. Transit riders from Lakeview chafed at having to switch from air-conditioned buses at the cemeteries to the older, poorly maintained streetcars. The company rode the tide of rider dissatisfaction to the city council in the summer of 1963 and secured approval to replace streetcars with buses on Canal Street. In typical New Orleans fashion, organized opposition arose only after the deal was done. By the following summer, one block of track remained of what was once a thriving four-track main line.

Buses have ruled Canal Street for almost 40 years. NOPSI was finally allowed to give up the city's transit system in 1983, and the New Orleans Regional Transit Authority (RTA) breathed new life into the notion of street railways in the city. The Riverfront line began operations in 1988. The one-block section of track on Canal was expanded in 1997, when the lower blocks of the street were used to connect the Riverfront with St. Charles Avenue, so the new streetcars could return to the uptown car barn. A combination of hard work on the part of RTA, city government, and elected officials in Washington secured approval to revive the Canal line. Construction of streetcars and track began in 1999, and the line went operational in the fall of 2003.

The role of Canal Street has changed dramatically during the 40-year hiatus of the streetcar line. The new streetcars won't be bringing people to a shopping district; that role has long since passed to suburban malls. The streetcar will offer a viable mass-transit option to downtown workers and locals going to the casino or the Quarter. It will also be an attractive way for tourists to venture away from the Quarter, to hopefully explore Mid-City and cemeteries at the end of Canal. The spur line on North Carrollton Avenue will entice visitors to the shops and restaurants along Carrollton, as well as giving them a comfortable ride to the New Orleans Museum of Art and City Park.

The history of streetcars on Canal Street does not have the romantic feel of its sister lines on Desire and St. Charles. It is a history of economics, of business, of going to work in the morning and going home to family in the evening. The Canal line was and is a story of unfailing dedication to servicing the citizens and visitors of New Orleans.

# One

# THE EARLY YEARS
## 1861–1895

Canal Street had been the starting point of the New Orleans and Carrollton Railroad's St. Charles line for over 30 years when streetcar service began up and down the street. The business objective of the New Orleans and Carrollton Railroad was to move residents of the Garden District from their homes uptown to the Canal Street retail and business district. The St. Charles line initially began as a steam railway, but the noisy steam engines annoyed the uptown residents so much that the company quickly switched operations to horse and mule power. Mules were the primary power source in New Orleans, because they are able to work longer hours in the city's hot, humid climate. This is evident even today in the French Quarter, where mules pull the tourist carriages.

Early street railway operations on Canal Street only involved turnaround track allowing the St. Charles line to return uptown. Track was not installed on the street's wide median, or neutral ground, until the 1860s. The New Orleans term "neutral ground" originated because of Canal Street's role as a boundary between the Creole section of the city and the American sections upriver from Canal Street. The boundary attracted a number of shops, churches, and businesses to Canal Street. By the peak of mule-powered street railway operations in the 1880s, Canal Street, from Rampart to the river, was a bustling commercial district. People of various ethnicities, freed slaves, and immigrants from Ireland, Germany, and Italy all changed the character of the original Creole-versus-American tension of Canal Street. By the time of electrification in the 1890s, Canal Street was no longer a line of demarcation, but the heart of the city.

By 1874, six companies, the Orleans Railroad Company, the New Orleans City Railroad Company, the New Orleans and Carrollton Railroad Company, the St. Charles Street Railroad Company, the Crescent City Railroad Company, and the Magazine Street Railroad Company, operated over 100 streetcars out of five barns, using over 600 mules. Additionally, the New Orleans City Railroad Company operated the West End line as a steam railway, before electrifying it in 1898. Because the mule-drawn cars were single-ended, a series of turntables were constructed on Canal Street allowing the cars to reverse direction.

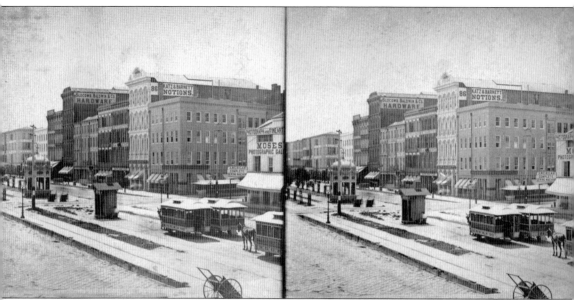

CANAL STREET GEOGRAPHY. Canal separates the Vieux Carré ("Old Square") or French Quarter from the "American Sector." The Americans were essentially shunned by the French/Spanish Creoles who originally settled the city. The Americans opted to re-name the streets when they were continued on the upriver side of Canal Street. So Rue Chartres became Camp, Rue Royal became St. Charles, Rue Bourbon became Carondelet, and Rue Dauphine became Baronne Street. Because the river turns so many times in the vicinity of New Orleans, simple north-south-east-west directions are impractical. Locals reference directions in terms of going "up" towards Lake Pontchartrain, or going "down" to the river. This photo looks inbound (towards the river) from just before the Clay Monument. Three cars are parked just before the starter's house at Camp Street, waiting to be turned around on the turntable at the end of the block. Across the street is a gazebo used as a passenger shelter. (Courtesy New Orleans Public Library.)

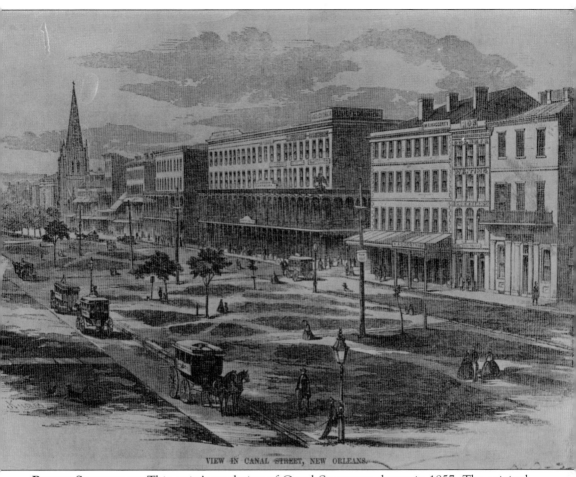

VIEW IN CANAL STREET, NEW ORLEANS.

**BEFORE STREETCARS.** This artist's rendering of Canal Street was drawn in 1857. The original plan for a canal had been abandoned by the 1830s, and the wide center of the street became a commons area, with walkways and landscaping. Note the omnibuses that were public transportation. This is the Canal Street that the float riders of the very first Carnival parade, the Mystick Krewe of Comus, would have seen. The steeple in the background of the illustration is Christ Church, the first Episcopal church in a predominantly Catholic city, is visible in the background, at the corner of Canal Street and Rue Dauphine. The congregation moved the church uptown to the corner of St. Charles Avenue and Sixth Streets in the Garden District. Isidore Newman then built his store, Maison Blanche, on the Canal Street lot. (Courtesy New Orleans Public Library)

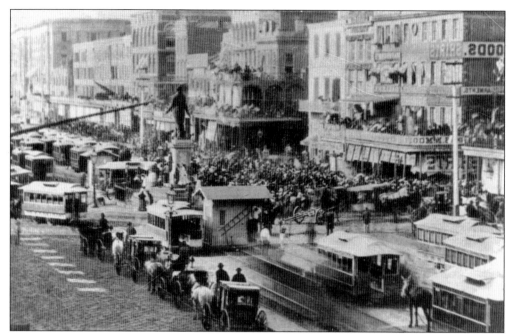

**THE TRANSIT HUB.** The Clay Monument faced the river, so this photo shows the view from the block between Carondelet and Baronne, looking towards the river. While there are no floats in view, the way the streetcars are bunched up and the alignment of the crowds indicate that there is a Carnival parade in progress, waiting for a float to turn from St. Charles Avenue (to the right of the statue) onto Canal. Below is an 1890 view, looking from Camp Street up to the Clay Monument. St. Charles Avenue begins to the left of the Clay Monument going upriver, and Royal Street starts to the right, heading into the French Quarter downriver. The large cars on the right are horse-drawn, not electric, since electrification didn't begin on Canal until 1895. At the center of the photo, an Orleans Railroad Company bobtail car is making the circle around the Clay Monument. (Courtesy New Orleans Public Library.)

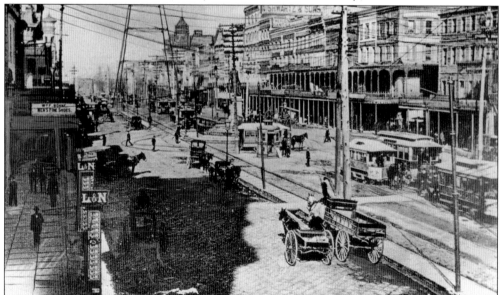

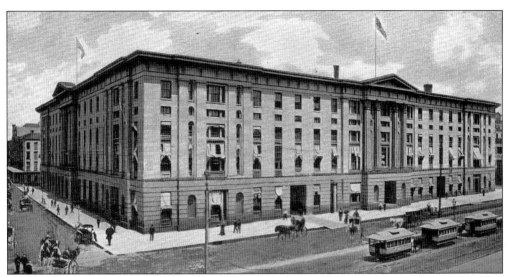

EARLY OPERATIONS. Horse-car operations on Canal were mostly concentrated between the Clay Monument and the river. Many lines ended in front of the Customs House at Peters Street. Construction began on the Custom House in 1848 but was not completed until 1881. Three bobtail cars can be seen in front. The New Orleans City Railroad operated a turntable in front of the Customs House for their French Market and Levee & Barracks lines. (Courtesy New Orleans Public Library.)

CANAL AND ST. CHARLES. This damaged Mugnier photograph shows a mule circling in front of the Clay statue at Canal and St. Charles. The Clay monument dominated what was at the time the business intersection on Canal. The track that circled in front of the statue belonged to the Orleans Railroad Company, for their Broad and Bayou St. John lines. (Courtesy of New Orleans Public Library.)

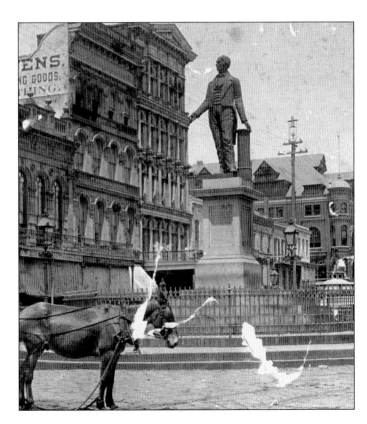

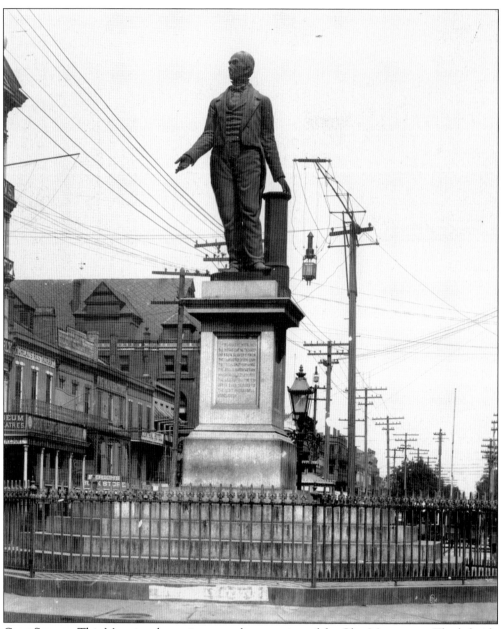

CLAY STATUE. This Mugnier photo gives us a close-up view of the Clay Monument. The left side of the photo is the "Uptown" side of town, which was referred to as the American Quarter and is now the Central Business District, or CBD. The statue, whose cornerstone was laid in 1856, was molded in Munich, Germany, and cost $50,000. It remained in the middle of the intersection of Canal and St. Charles until 1901, when it was moved down the street to Lafayette Square. (Courtesy New Orleans Public Library.)

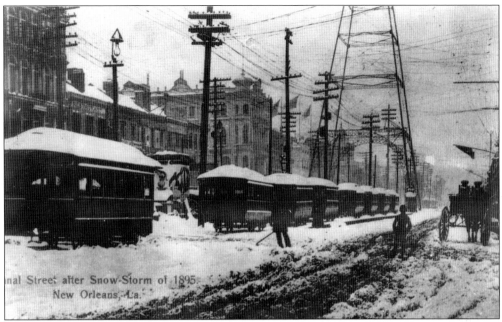

nal Street after Snow-Storm of 1895.
New Orleans, La.

LET IT SNOW! Snowfalls in New Orleans are a rare event. This one, in 1895, left enough snow to top off the streetcars. This view is from Royal Street looking lakebound. The Chess, Checkers, and Whist Club is visible in the center background. The St. Charles Street Railroad Co. and the New Orleans City Railroad Co. had electrified most of their operations by the end of 1895, but the snowstorm forced both companies to bring out the bobtails. (Courtesy New Orleans Public Library)

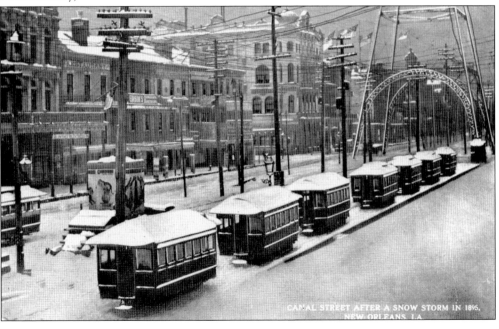

CANAL STREET AFTER A SNOW STORM IN 1895.
NEW ORLEANS, LA.

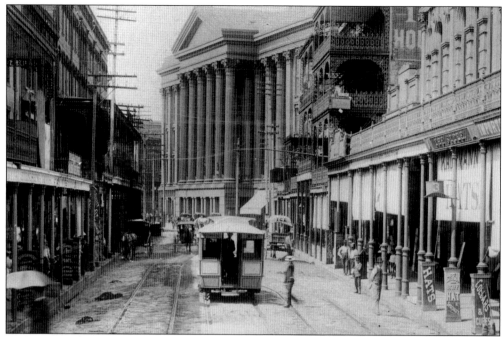

**RETURNING UPTOWN.** A St. Charles Street Railroad Company car has turned off Canal Street onto St. Charles Avenue for its return trip Uptown. The large building in the background is the very popular St. Charles Hotel. Although the operating company changed hands several times over the years, the St. Charles line has operated continuously since 1934, the longest-running streetcar line in the United States. In 1971, the St. Charles Line was placed on the National Register of Historic Places. (Courtesy New Orleans Public Library)

**LOOKING RIVERBOUND.** This Howell photo captures the Custom House looking riverbound. The tracks in the foreground are terminal tracks for lines emerging from Chartres and Royal Streets. The tracks directly in front of the Custom House are terminals for lines on both the French Quarter and business district sides. The rear of a bobtail car is just visible on the far right.

**LOOKING LAKEBOUND.**
The neutral ground was adorned with rows of trees in this Blessing stereopticon photo. Two bobtail cars can be seen through the trees at the corner of Canal and Camp Streets. Clay is visible in the center-right background. The tracks at Camp Street at this time were three-across. The two on the uptown side converged on a turntable, and the track on the French Quarter side was a through track to the Clay Monument. (Courtesy New Orleans Public Library.)

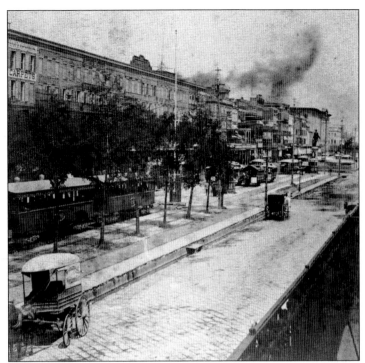

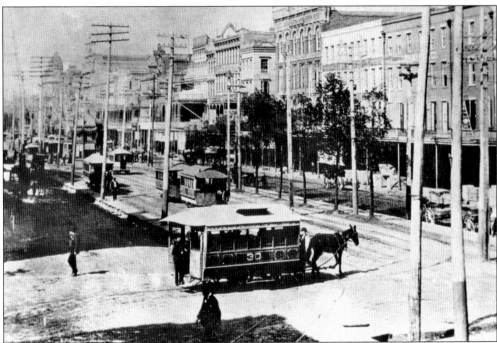

CROSSING CANAL. This photo shows Canal from Magazine Street, looking out towards Lake Pontchartrain. The car in the foreground is turning onto the outbound, or lakebound outside track. It is approaching and will pass next to two cars on the inside lakebound track. These tracks all stop a block up, near the ornate gazebo in the center of Canal Street's "neutral ground."

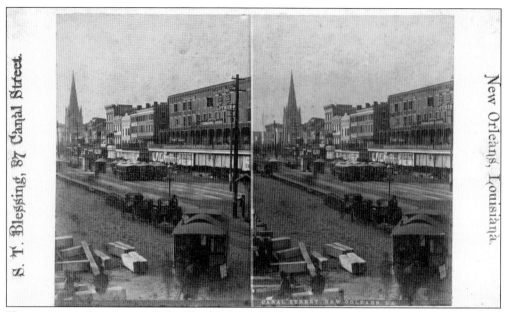

HORSECARS IN OPERATION. A St. Charles Street Railroad horsecar is turning onto St. Charles Avenue in the foreground. New Orleans City Railroad cars are three-across in the center of the photo. Behind them, another car is on the turntable at the corner of Carondelet (Bourbon) and Canal. The steeple of Christ Church can be seen on the left, indicating that this stereopticon card was shot prior to 1883. Below, this street level view gives a better sense of just how wide Canal Street is. The Clay Monument, in the center of the neutral ground, is on the left side. An Orleans Railroad horsecar is circling in front of the monument as two unidentified men survey the block between St. Charles and Camp. The photo, by William S. Howell, was taken on March 15, 1890, at 3:45 p.m. (Top, courtesy Louisiana State Museum; bottom, courtesy New Orleans Public Library.)

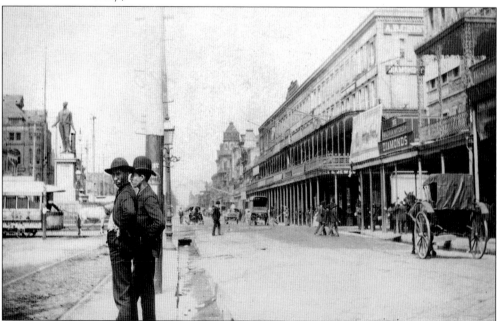

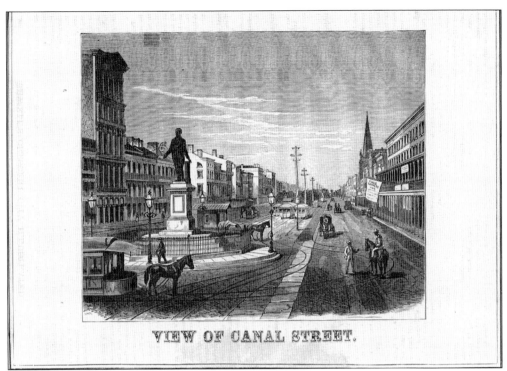

VIEW OF CANAL STREET.

**ILLUSTRATED VIEW.** This illustration gives a better view of the tracks around the Clay Monument than the photos. An Orleans Railroad Broad or Bayou St. John mule car circles the monument in the foreground while three cars are positioned on the tracks in the block between St. Charles and Carondelet. The tracks are five-across in that block in the early 1880s. (Courtesy New Orleans Public Library.)

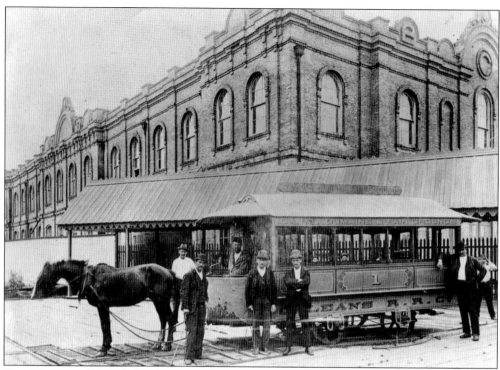

THE "BOBTAILS." The bobtail cars ran along Canal Street until the lines operating there were electrified from 1895 to 1900. This car, Number 1 of the Orleans Railway Company, is marked as "Canal, Dumaine & Fair Grounds" meaning its route went on the downriver side of Canal, then out to Gentilly Road and the Fair Grounds horse racing track. This line became the Broad Street line when the company was merged into NOPSI in 1922. Below, another street-level view looks from Chartres Street towards the river. The trees in the neutral ground are bare in this wintertime photo. (Courtesy New Orleans Public Library.)

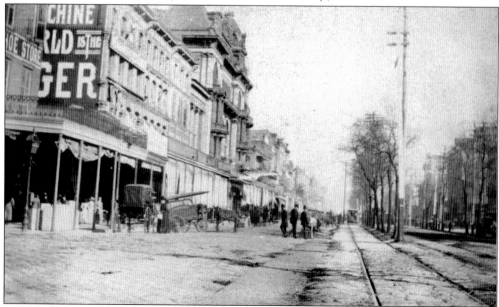

**OUTSIDE THE CBD.** Canal Street looks very suburban in these two photographs shot just after the Civil War. Outside the business district, Canal Street's neutral ground was grass-covered, and it remains that way to this day. After Claiborne Avenue, the character of Canal Street changes completely, shifting from the main street of the business district to a wide residential boulevard. The New Orleans City Railroad Company operated the Canal line all the way to the cemeteries. (Courtesy New Orleans Public Library.)

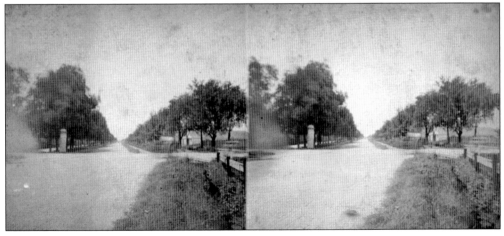

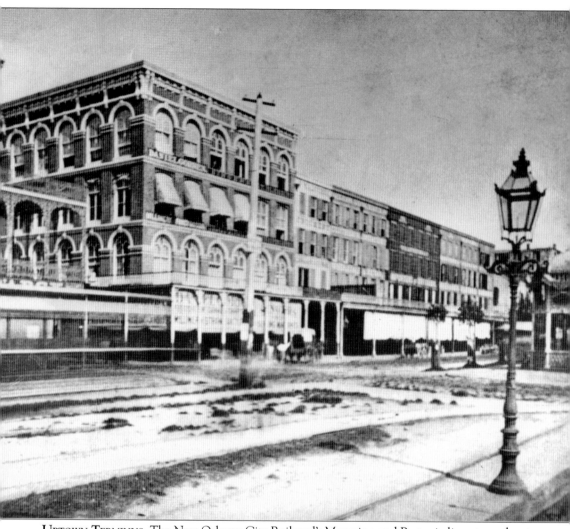

**UPTOWN TERMINUS.** The New Orleans City Railroad's Magazine and Prytania lines turned onto Canal here, terminating at the turntable just behind the photographer. The single track from Camp splits into two for the turntable approach, and a third through track is in the background. A car has just passed by on the through track, causing the blurring on the left-hand side of the photo. When the lines were electrified in 1895, the turntable was removed and the track re-worked so the lines approached Canal from Camp, turned riverbound onto Canal, then turned onto Magazine Street for the return trip uptown. Both lines began operations in the summer of 1861, with Prytania being converted to buses in 1935 and Magazine in 1948. (Courtesy New Orleans Public Library.)

# Two

# THE GOLDEN AGE OF
# ELECTRIC STREET RAILWAYS
## 1895–1922

*From the Gay Nineties to the Roaring Twenties, the United States enjoyed almost 40 years of prosperity and growth. Across the country, street railways were growing at a rapid rate and New Orleans was no exception. The 1890s saw the electrification of all the horse lines in the city, as well as the West End line, which had previously been steam-powered. The old bobtail mule cars were initially replaced by single-truck (four-wheel) streetcars. By 1918, there were 365 of these cars, purchased from twelve different manufacturers. Double-truck (eight-wheel) models held more people and were purchased for the more popular and crowded lines. When passenger volume continued to grow, these busier lines started two-car operations, in which a powered car would pull a trailer behind it.*

*Most of the cars that operated in New Orleans during this "golden age" of street railways were "semi-convertible." Instead of "convertible" cars, in which side panels were placed on the cars during cold weather, the New Orleans railway companies opted to use cars with sliding windows that could be closed during rainy or cold weather. The New Orleans City Railroad Company operated "Palace" cars from the St. Louis Car Company on the Canal line. These were elegant cars, with larger seats and a style that suggested comfort and leisure. The West End line was both a commuter and an excursion line. It carried commuter traffic because it went up Canal Street to the cemeteries, but then turned left on City Park Avenue and followed the New Basin Canal out to the lakefront. Excursions out to Lake Pontchartrain were still considered day-trips at this time; the residential subdivisions in the Lakeview section of the city would come later.*

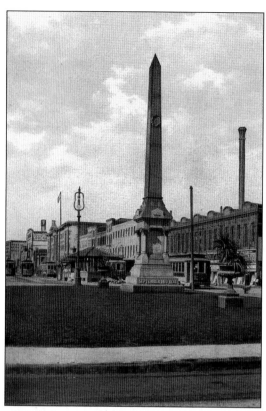

**THE FOOT OF CANAL STREET.** The Liberty Monument was the turnaround point for the Canal line. Erected in 1891 to commemorate the 1874 "Battle of Liberty Place," the monument has had a controversial history and is now located a block off of Canal Street, in front of a parking garage. This postcard shows a single-truck electric car coming out of the loop around the monument. Note that the overhead catenary wires have been brushed out. (Courtesy New Orleans Public Library)

**"PALACE" CARS.** In this photograph of three "Palace" cars on the West End line, the center car illustrates a good example of two-man operation. The operator is lounging in the front of the car while passengers are boarding at the rear. They pay the conductor as they enter. (Courtesy of New Orleans Public Library.)

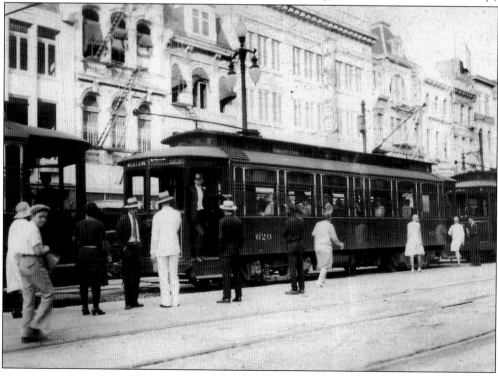

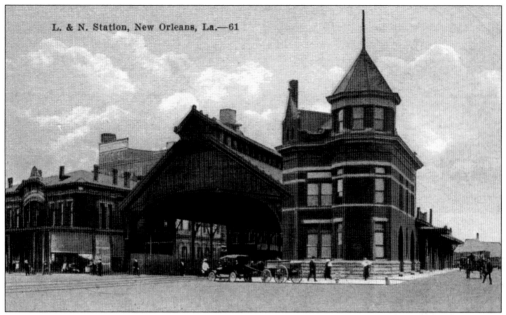

L. & N. Station, New Orleans, La.—61

MAKING CONNECTIONS. This view shows the Louisville and Nashville Railroad station at the foot of Canal in 1902. Prior to 1953, New Orleans was serviced by five separate passenger train stations, each railroad operating their own. The L&N station was on the French Quarter side of Canal Street. A power transmission substation now stands on the spot. Below is a map of the New Orleans and Carrollton Railroad Company's operations in 1901. The NO&CRR primary route was the St. Charles Line, which is why their Canal operations only extend from Claiborne to the River. (Courtesy New Orleans Public Library.)

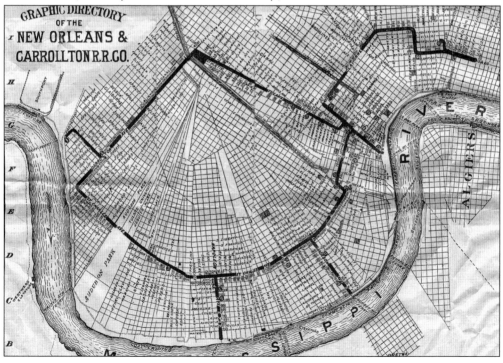

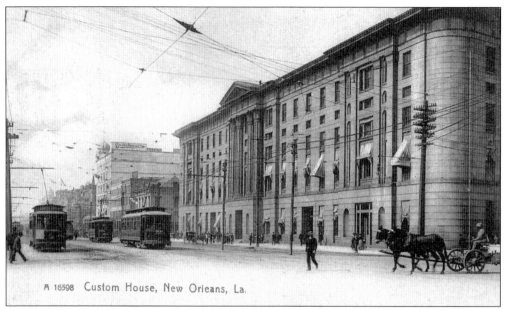

A 16598  Custom House, New Orleans, La.

CUSTOM HOUSE. These two views are of the Custom House, which occupies the block from Front to Decatur on the French Quarter side. These photos date from 1905 to 1909. Above, a single-truck Ford, Bacon, Davis car, 188, is inbound to the river. To the right, a double-truck "Palace" car follows a single-truck car on the lakebound track. Below, what looks like a single-truck car is actually a Brill-built double-truck model. These cars had derailment problems and were replaced on most lines with single-truck cars by 1900. This car is turning onto Canal from North Peters. (Courtesy New Orleans Public Library.)

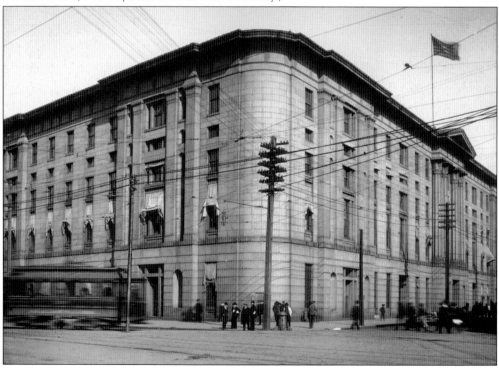

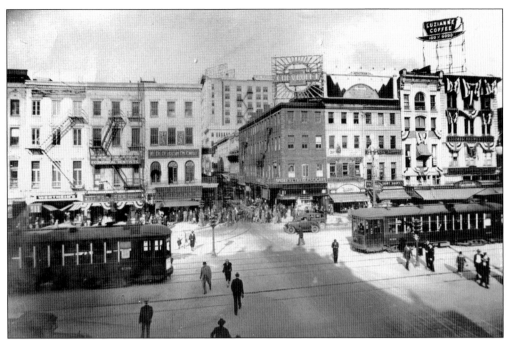

**THE 400 SERIES.** Two 400-series arch roof cars prepare to pass each other at Canal and Bourbon Streets. The 400-series were the first arch roof cars designed by Perley A. Thomas to be used in New Orleans, starting in 1915. They were phased out when the 800- and 900-series cars began operation in the mid-1920s. (Courtesy of New Orleans Public Library.)

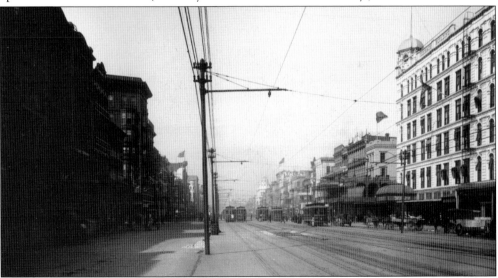

**LOOKING LAKEBOUND.** This street-level shot gives a splendid view of Canal Street's four-track operation. On the left are two inbound single-truck cars. There are three cars on the outbound tracks on the right. In the right foreground is the Godchaux Building, at Canal and Chartres. The photographer is standing at the corner of Canal and Magazine Streets. Note that the turn-of-the-century landscaping in the neutral ground between Camp and Magazine (Chartres and Decatur) is gone, as are the turntables used to reverse the direction of the bobtail cars. (Courtesy New Orleans Public Library.)

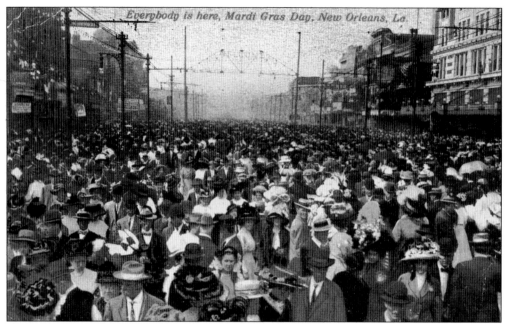

CARNIVAL TIME. Above, this photo—shot before 1910—repudiates the myth that people used to dress in costume for Carnival more in earlier times than they do now. Canal Street is wall-to-wall people for blocks as a parade passes. Below is another photo from Carnival season. Streetcars were usually pulled out of the neutral ground during parades, lest the crowds damage the cars, so this concentration of cars is unusual. Note the mules pulling the parade float. (Courtesy New Orleans Public Library)

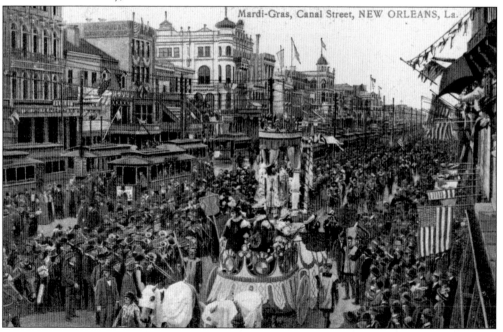

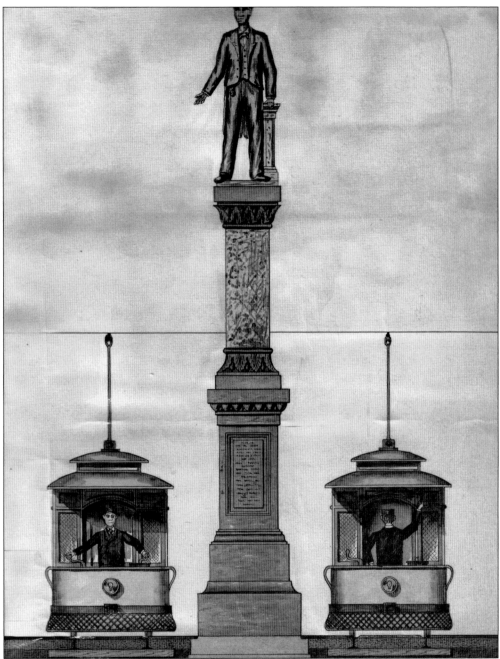

CHANGES TO THE CLAY MONUMENT. When unveiled on April 12, 1860, the Henry Clay Monument took up the entire center of the intersection of St. Charles Avenue and Canal Street. With the electrification of street railways on Canal, changes had to be made to the statue's massive base. This drawing, from a proposal to the City Council, shows the extent to which the base of the statue was to be modified to allow the two center tracks to pass unobstructed. Note that the artist was not too aware of how streetcars operated, since the overhead wire has been drawn across the two lanes! There were, of course, two wires running in parallel with the streetcars. (Courtesy New Orleans Public Library.)

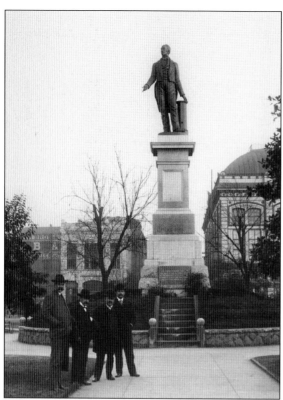

**HENRY CLAY, RELOCATED.** The Clay Monument was removed from Canal and St. Charles in 1901. It was relocated down St. Charles Avenue to Lafayette Square, across from City Hall. That building is now referred to as Gallier Hall, after its architect, since a new City Hall building was constructed in the 1950s. (Courtesy New Orleans Public Library.)

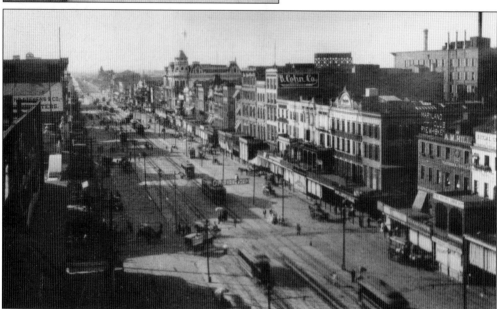

**SINGLE-TRUCK OPERATIONS.** Horse-drawn carts carefully cross Canal Street as a number of single-truck streetcars operate in both directions. Allison shot this photo in 1905 from the Morris Building. In the right foreground, a Ford, Bacon, Davis car is heading outbound on the outside track, while in the center of the photo two other cars are on the inside outbound track. (Courtesy New Orleans Public Library.)

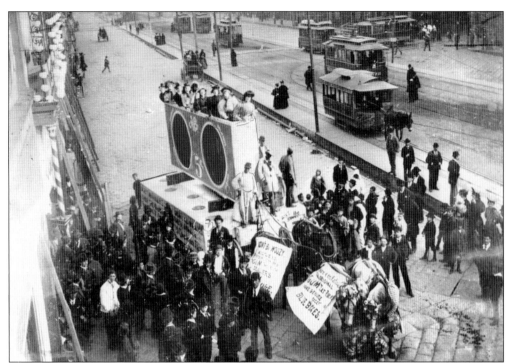

**ADVERTISING PARADE.** A wagon promoting chewing gum draws a crowd as it makes its way towards the river. Lots of streetcar activity occurs in the neutral ground. In the foreground, a bobtail horsecar from the Canal and Claiborne Railroad Company moves riverbound. The C&C Railroad electrified all their horsecars by 1896, so this picture dates from 1894 or 1895. In the center, several single-truck cars move in both directions. (Courtesy New Orleans Public Library.)

**KATZ AND BESTHOFF.** Electrification also came to advertising at the turn of the century, as illustrated by this photo of the original K&B drugstore at 732 Canal. The chain grew to over 160 stores, ranging from Texas to Florida, and was sold in 1998 to Rite Aid. The chain's trademark purple logo and shopping bags made K&B customers instantly recognizable on the street. (Courtesy New Orleans Public Library.)

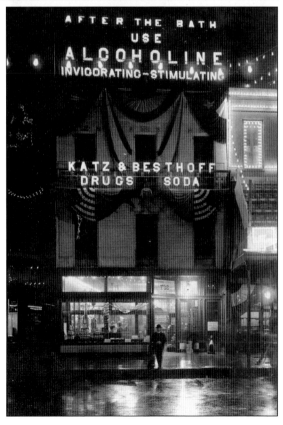

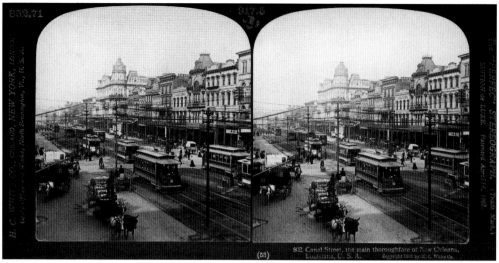

MIXED OPERATIONS. Above, in the foreground, car 184 of the New Orleans & Carrollton Railroad is on the outside riverbound track in this photo from 1898 or 1899. Another NOCRR car is on the outer right-hand side of the photo, on the lakebound track. Just popping into view on the far right is a New Orleans City Railroad car, with a different color scheme from the others on the street. In the left background is a West End train and its trailer/baggage car. A motorized car would pull one or two trailer cars behind it. There were several crossovers between the center tracks so the motor car could run around the unpowered cars and put them into proper position. Below, a lakebound "Palace" car waits at the corner of Canal and St. Charles with a riverbound single-truck car. A number of cars are moving in both directions on the center set of tracks, an indication of how busy the Canal line was. (Top, courtesy Louisiana State Museum; bottom, courtesy New Orleans Public Library.)

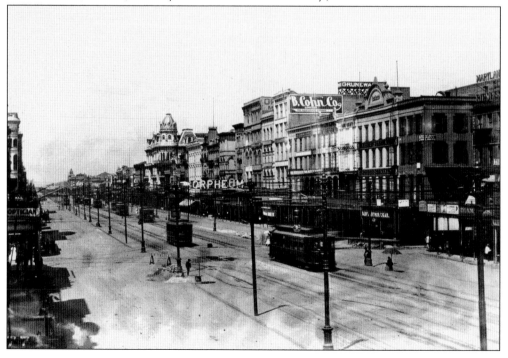

CARNIVAL NIGHTS. The various social and lunch clubs are associated with one or more of the carnival organizations. For the parades, the clubs set up grandstands so their members and guests could view the parades. The club affiliated with that evening's parade would also host the organization's queen and court. The king's float of the parade would stop so the king could toast his queen and the club's membership. Above, the Louisiana Club honors the Krewe of Proteus (KOP), February 26, 1906. Momus no longer parades, but Proteus still parades down St. Charles Avenue and Canal Street. Below, the wide-angle shot shows the Boston and Chess, Checkers and Whist Clubs on the left, an electric sign advertising West End across the street, and the old Maison Blanche store on the right. (Courtesy New Orleans Public Library.)

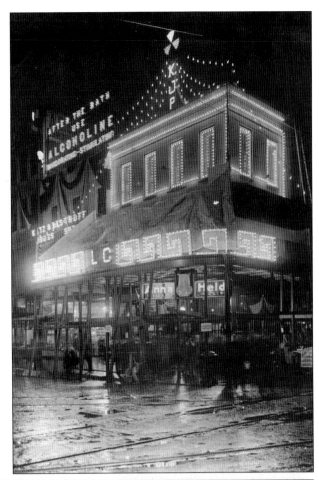

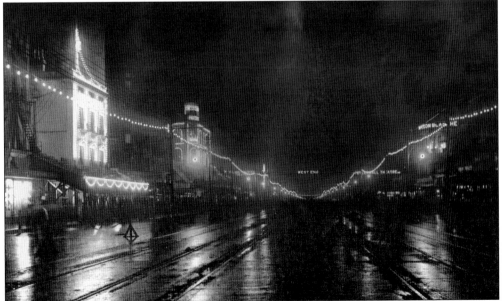

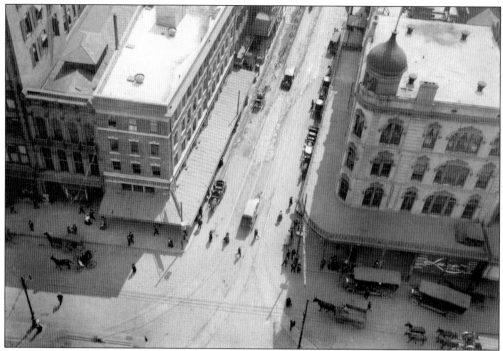

CANAL AND BARONNE STREETS. The corner of Canal and Baronne was a busy one. The Jackson Avenue and Tulane Belt lines began their return runs uptown on Baronne Street. Above is an Allison photo, shot in 1910. He's looking down at the corner from the new Maison Blanche building. Note that the tracks from Baronne feed the outer tracks on either side of the main Canal tracks; the lines that only used Canal as a termination/restart point did not go on the center tracks. (Courtesy New Orleans Public Library.)

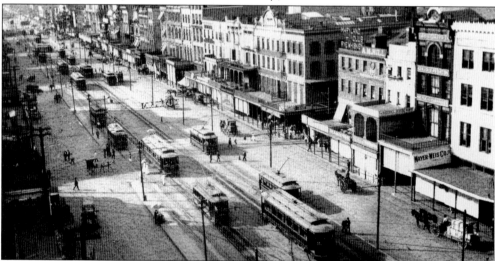

CBD ACTIVITY. This photo is a good illustration of the mix of double-truck "Palace" cars on the main Canal line, while single-truck cars occupy the outside tracks on either side. The single-truck cars, coming to Canal Street from all parts of the city, converge on the Central Business District to accommodate workers and shoppers. (Courtesy New Orleans Public Library.)

34

**CHESS, CHECKERS, AND WHIST.**
Unlike the Boston and Pickwick
Clubs, which are primarily social/
lunch organizations, the Chess,
Checkers, and Whist Club took
the games seriously, sponsoring
chess tournaments that drew world
champions like New Orleans
native Paul Morphy. Above is a
Milo Williams photo of the same
intersection from street level. A
single-truck car is just appearing
on the outside riverbound track.
The building on the right is the
Chess, Checkers, and Whist
Club. Below, the club at night
is illuminated for Carnival. The
"KOM" on top stands for "Knights
of Momus," one of the oldest
Carnival organizations in the
city. (Top, courtesy New Orleans
Public Library; bottom, courtesy
Louisiana State Museum.)

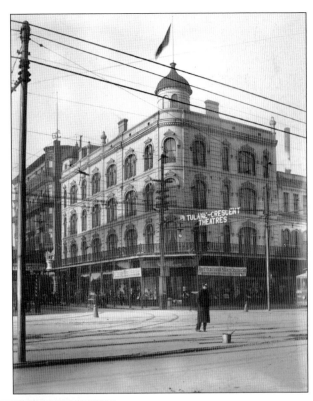

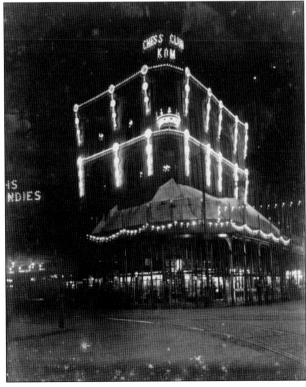

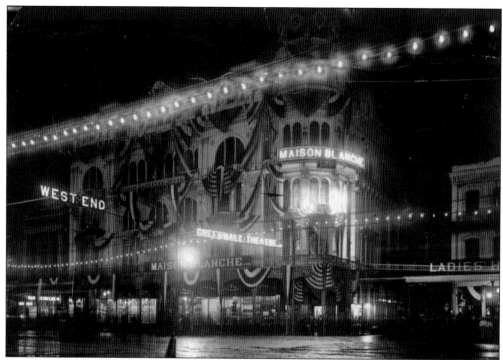

**MAISON BLANCHE.** The corner of Dauphine and Canal was the original location of Christ Church. When the Episcopal congregation moved to St. Charles Avenue in 1883, Isidore Newman built a department store, Maison Blanche (literally "White House"), on the site. Above, the store is lighted for Carnival in 1906. Below, this Allison photograph shows the Maison Blanche building in 1906. Two Ford, Bacon, & Davis cars are on the outer tracks, with another single-truck car on the center inbound track. The cars are stopped at Bourbon Street to allow pedestrians to cross Canal. (Courtesy New Orleans Public Library.)

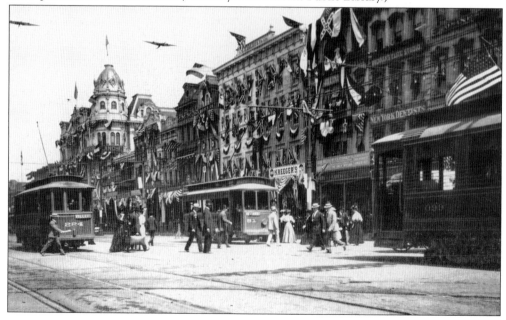

**FORD, BACON & DAVIS.** The most popular of the single-truck streetcars, close to 350 FB&D cars operated in New Orleans. The cars were built between 1896 and 1908 by three companies: American, St. Louis, and McGuire-Cummings. Seating 28 passengers, the FB&D cars were originally designed for the Canal and Claiborne Railroad Company. The FB&Ds were retired in 1932. Above, the wide celestory roof of the FB&D model is visible on the cars waiting for a parade to pass. Below, a FB&D car heads lakebound in front of the Custom House. Note the street vendor's wagon and umbrella in the bottom left. (Courtesy New Orleans Public Library)

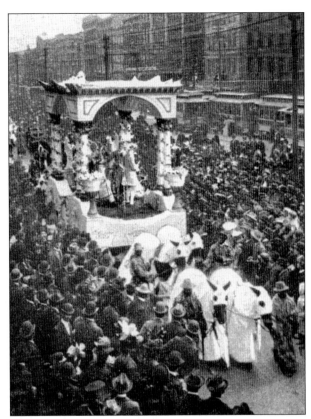

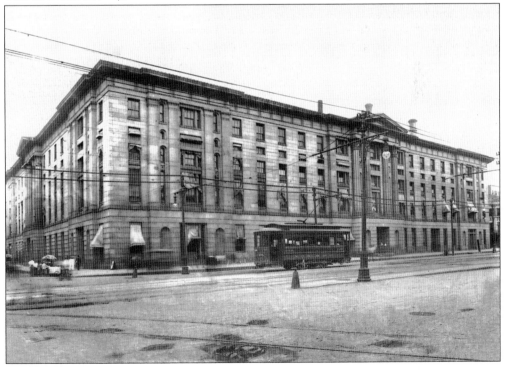

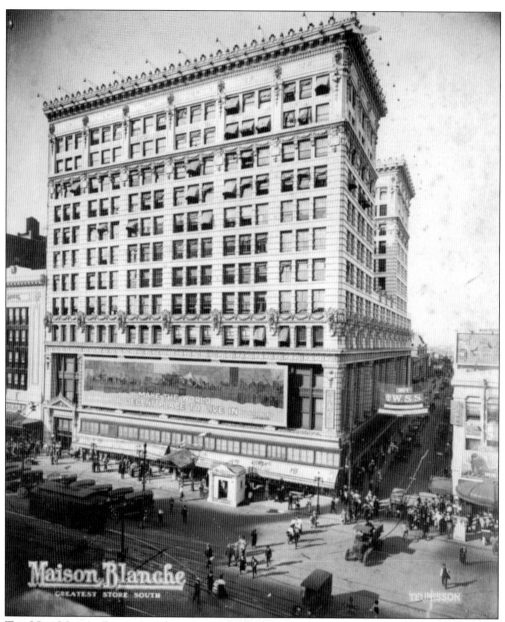

**THE NEW MAISON BLANCHE.** The original Maison Blanche building was torn down in 1908 and a new building constructed in its place in 1909–1910. A single-truck car passes automobiles that are angle parked against the neutral ground. The first five floors of the building were for the store, and the rest of the building was leased as office space. The Maison Blanche building was the home of one of the city's original radio stations: WSMB (the "S" was for the Saenger Theater, the "MB" for Maison Blanche). The Maison Blanche stores were acquired by the Dillard's department store chain in the 1990s and the Canal Street building was converted to a hotel in 2000. (Courtesy Louisiana State Museum.)

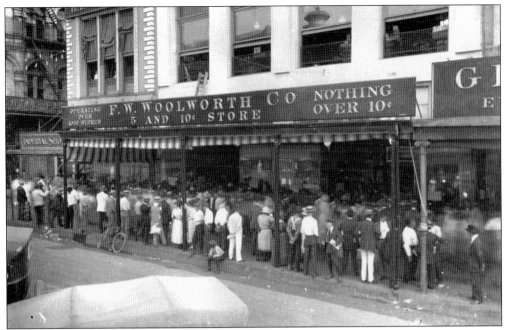

WOOLWORTH'S. Shoppers wait for the opening of the F.W. Woolworth store at the corner of Canal and Burgundy. From Rampart to the river, Canal Street was New Orleans's shopping hub for over a century. Stores ranging from Woolworth and S.H. Kress to the department stores like Maison Blanche, D.H. Holmes, and Godchaux's, along with drugstores and other specialty shops, enticed locals to get on the streetcar and ride downtown. (Courtesy Louisiana State Museum.)

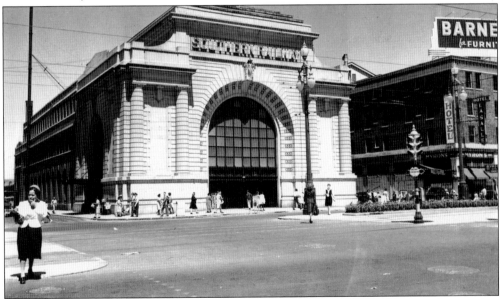

MORE CONNECTIONS. Southern Railway was the main method of transportation for travelers looking to come to New Orleans from Atlanta and points on the East Coast. The station, located at Canal and Rampart, is one of the reasons so many streetcar lines converged in that block. (Courtesy New Orleans Public Library.)

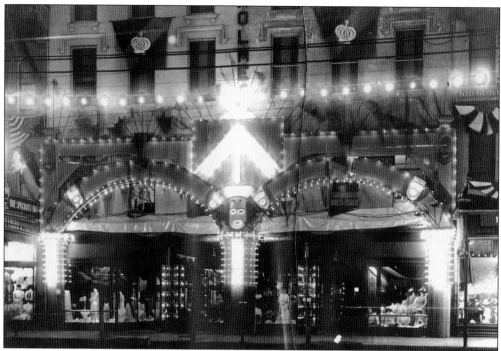

**D.H. HOLMES.** The store made famous by John Kennedy Toole in his novel *A Confederacy of Dunces* lit up for Carnival. Holmes was a New Orleans fixture until the local company merged with the Dillard's department store chain. (Courtesy of New Orleans Public Library.)

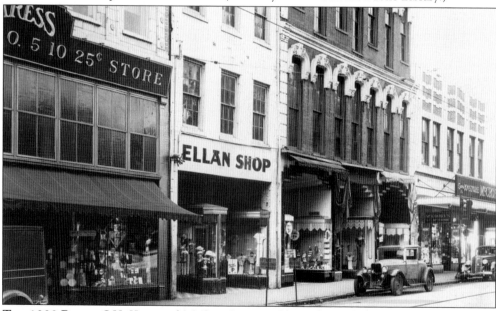

**THE 1000 BLOCK.** S.H. Kress and McCrory's are visible in this early 1920s photo of the 1000 block of Canal, on the French Quarter Side. Many of the stores operating in this part of Canal have come and gone, with the upper floors being leased as office and apartment space. A number of these buildings still exist today and have been converted into hotels. (Courtesy New Orleans Public Library.)

CARONDELET STREET. A single-truck car has just turned off of Canal Street. Car 233 is running on either the Annunciation, Coliseum, or Henry Clay lines. These are actually two versions of the same photograph. Above is the color postcard. The building looming on the right-hand corner is the L. Feibleman and Company department store. (Courtesy New Orleans Public Library.)

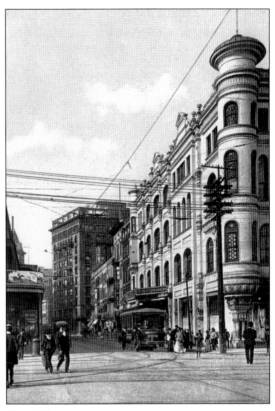

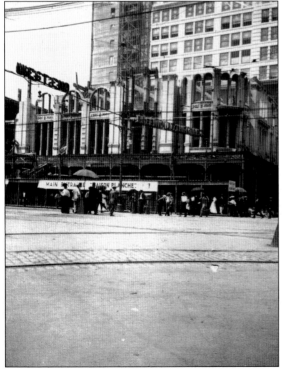

CHANGING TIMES. Canal Street's role as the city's retail center meant changes as stores came and went. The photo captures the demolition of the old Maison Blanche building in 1910. The store chain, founded by local philanthropist Isidore Newman, was sold to Dillard's in the 1990s.

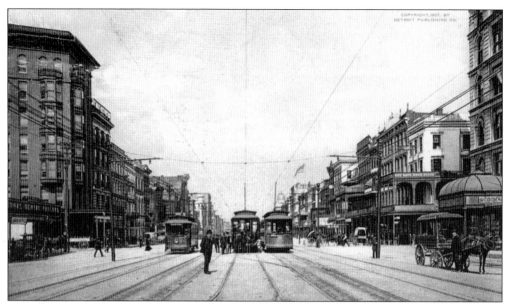

**STREET LEVEL.** The trackage is five-wide at the corner of Canal and Chartres Streets. A horse cart has just passed the entrance to the Godchaux building on the left. A lakebound "Palace" car is flanked by two single-truck cars, one running parallel to the double-truck car, the other heading riverbound on the outside track. The car on the left will most likely turn onto Magazine Street and head uptown. (Courtesy New Orleans Public Library.)

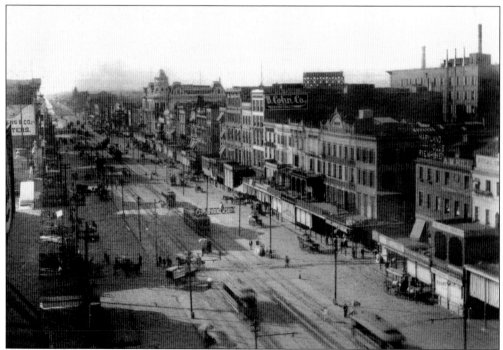

**"PALACE" ACTIVITY.** Two "Palace" cars prepare to pass each other as they cross Carondelet Street, while a single-truck car moves riverbound on the outside track on the left. The new Maison Blanche building looms in the background. (Courtesy New Orleans Public Library.)

**THE BOSTON CLUB.** Lit up for parades, the Boston Club's grandstands are empty as the parade has gone by for the evening. Several of the luncheon clubs and the Carnival organizations affiliated with them ran afoul of city government in the 1990s, and many now do not erect grandstands on Canal, so as not to use city facilities, in response to an "anti-discrimination" ordinance passed in 1992 by the city council. In spite of winning court victories over the City, the clubs have yet to re-appear on Canal during Carnival. (Courtesy New Orleans Public Library.)

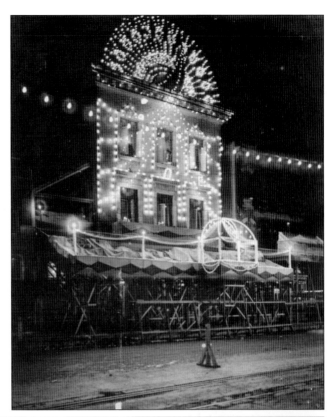

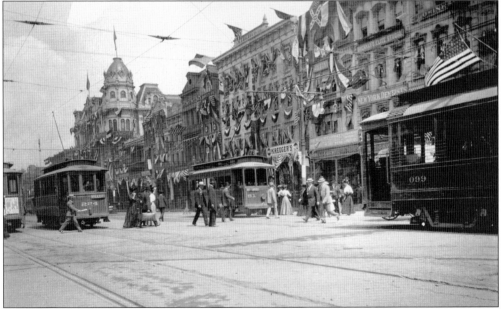

**MORE FORD, BACON & DAVIS.** A lakebound "Palace" car at the right waits to cross Bourbon Street. Three Ford, Bacon & Davis cars are on the other side of Bourbon, two headed riverbound, one going lakebound on the outside track. Note the wood running boards just above the numbers of the single-truck cars. (Courtesy New Orleans Public Library)

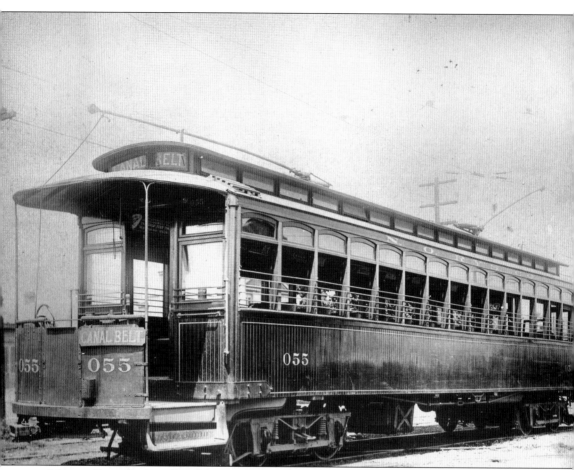

**MORRIS CARS.** Built at Canal Station between 1900 and 1902, these cars were named after E.J. Morris, the master mechanic at the Canal Shops. The original design was the open platform shown in the photo, but this was changed to a vestibule in 1904. The Morris cars ran on the Canal and Esplanade Belt lines. From 1901 to 1934, the line ran as two one-directional "belts." The Canal Belt started at Liberty Place, outbound on Canal to City Park Avenue. It turned right on City Park to Moss Street, then left and right again, crossing Bayou St. John at Esplanade and headed riverbound on Esplanade. At North Rampart, the line turned right and headed back to Canal, turned onto the center-line riverbound track, back to the loop. The Esplanade Belt also started lakebound on Canal from Liberty Place, but turned right on North Rampart, then left on Esplanade, then Moss, then City Park Avenue, then turned left again back onto Canal at the cemeteries. (Courtesy New Orleans Public Library.)

Bird's-eye View, showing the Historical French Quarter, New Orleans, La.

LEAVING DOWNTOWN. The concrete neutral ground of the Central Business District gives way to grass and trees a couple of blocks after Southern Railway station at Rampart Street. A single-truck car is heading outbound on the inside track, while several double-truck cars idle near the train station. The tree-lined boulevard running across the center of this postcard is North Claiborne Avenue. This beautiful street was ripped up in the 1970s to make way for the I-10 highway. Below, an unidentified man cuts the grass on the neutral ground at Canal and Salcedo with a push-style mower. This 1914 photo is looking towards the lake. Note that Canal Street maintains its width even outside the business district. (Courtesy New Orleans Public Library.)

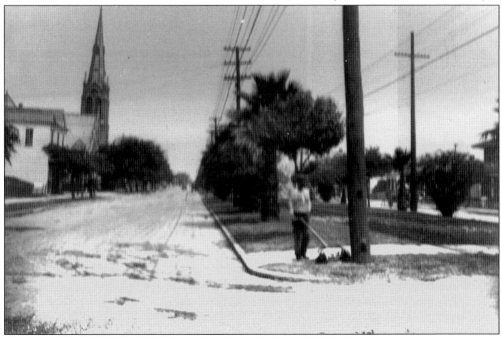

CANAL AND SALCEDO. These photos show the intersection of Canal and Salcedo Streets, looking lakebound. Shot in 1914, the steeple a block up the street is that of Sacred Heart Church. This church was torn down in the 1920s and replaced by the current church. A "Palace" car is barely visible in the left background of the bottom photo, heading toward downtown. (Courtesy New Orleans Public Library.)

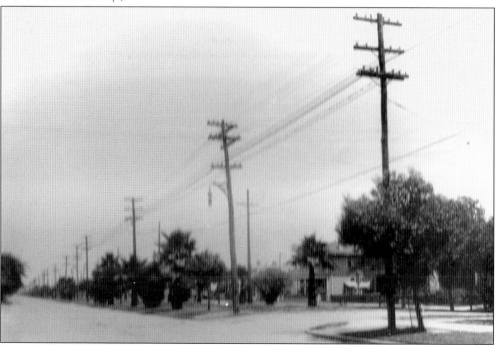

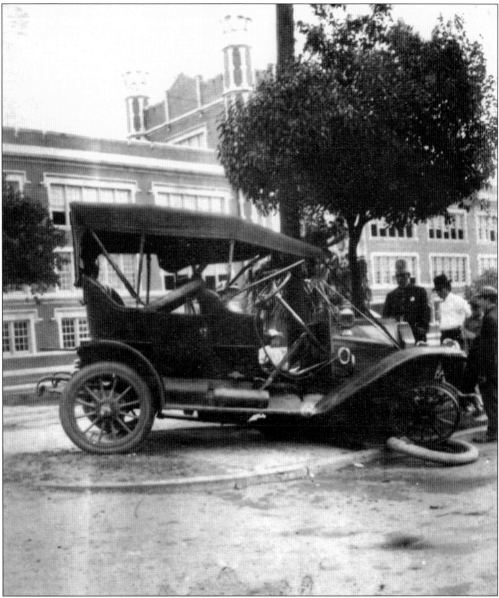

**NEVER ARGUE WITH A STREETCAR.** This automobile crossed the neutral ground at Canal and Salcedo Streets and was hit by a New Orleans Railway and Light Company streetcar. No car has ever won such a confrontation, on any street of New Orleans, since steel streetcars went into operation. It is unknown if the driver or passengers were injured. The school in the background was originally known as the Boy's School, now Warren Easton Senior High. (Courtesy New Orleans Public Library.)

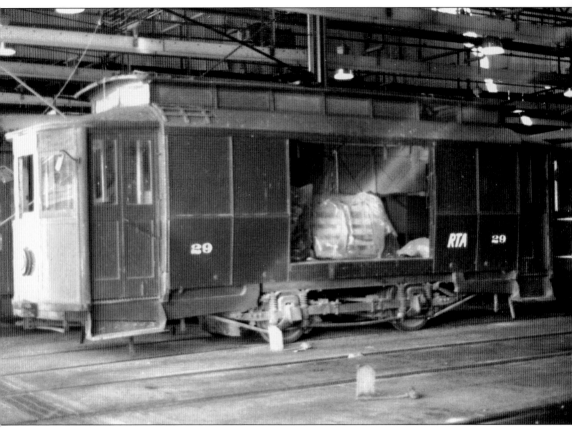

THE LAST FB&D. Car 29 is the last existing Ford, Bacon & Davis streetcar. Measuring 29 feet, 4 inches long and 8 feet wide, the FB&Ds cost around $3,000 (in 1898 dollars). Car 29 was one of the few FB&Ds that originally had a McGuire "Columbian" truck rather than the more popular "Lord Baltimore" truck that became a standard for New Orleans operations. (The car now has a 21-E truck.) NOPSI kept and maintained car 29 when it scrapped the remaining FB&Ds in 1932. The car has served in a number of roles over the years, as a rail grinder, general maintenance support, and as a sand car for the St. Charles line. Car 29 was taken out a few times in the 1960s for streetcar preservationists, but now the car is totally in a work configuration. The Ford, Bacon & Davis cars were so popular that many other Southern cities, including Shreveport, Montgomery, and Birmingham, acquired and operated them. (Courtesy the author's collection.)

# *Three*

# THE ARCH ROOF ERA
## 1922–1953

*The arch-roof streetcar is the style most intimately associated with New Orleans. These streetcars have operated on St. Charles Avenue since 1915. Arch-roof cars inspired Tennessee Williams to write* A Streetcar Named Desire. *The first series of these cars was the 400s, ordered by the New Orleans and Carrollton Railroad in 1915. The 400s were designed by Mr. Perley A. Thomas and were built by Southern Car Company. Mr. Thomas continued to build the arch-roof cars when he started his own business, the Perley A. Thomas Company, of High Point, North Carolina. The Perley A. Thomas Company became Thomas Built Buses, which has since been acquired by (and is now a division of) General Motors.*

*When transit operations were taken over by New Orleans Public Service, Incorporated, in 1922, the company ordered additional arch-roof cars. Between 1922 and 1924, 97 cars were built by Perley A. Thomas and another 76 by Brill, using Mr. Thomas's design. There were four series of arch roof cars operated in New Orleans: the original 400s, the 800-series, the 900-series (which are still operated on the St. Charles line), and the 1000-series, which were not operated on Canal Street. The remaining 900-series cars in New Orleans are the last "conventional" (pre-PCC) streetcars still in operation.*

*The arch-roof style cars did not simply replace existing streetcars in service. New Orleans Public Service, Incorporated phased in the new cars over an extended period of time. Canal Street saw a wide variety of streetcars in operation: single-truck cars continued to operate on low-traffic lines until the 1930s and the "Palace" cars were the mainstay of the Canal Line into the 1930s as well. The Perley Thomas cars initially replaced the various semi-convertible cars in operation on lines other than Canal, finally replacing the "Palace" cars on the center tracks.*

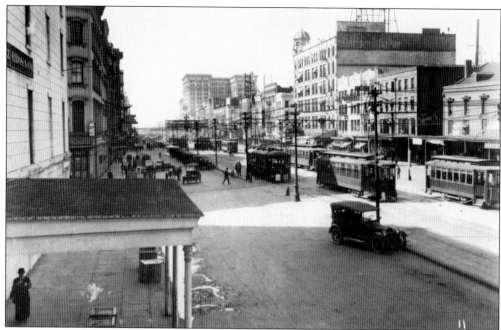

THREE GENERATIONS. An arch roof car heads riverbound on the outside track at left. On the inside riverbound track, a "Palace" car also heads towards the eight-track terminal in front of the Custom House. On the outside lakebound track, a Ford, Bacon & Davis single-truck car is preparing to turn back into the French Quarter. This Teunisson photograph is undated, but the intersection of three generations of streetcars and the types of automobiles on the street put it in the mid- to late 1920s. Below, a Perley Thomas car turns onto Canal, on the outside track, following a single-truck car riverbound. A "Palace" car is heading lakebound, and another Perley Thomas car prepares to turn off of Canal on the outside lakebound track. (Courtesy Louisiana State Museum.)

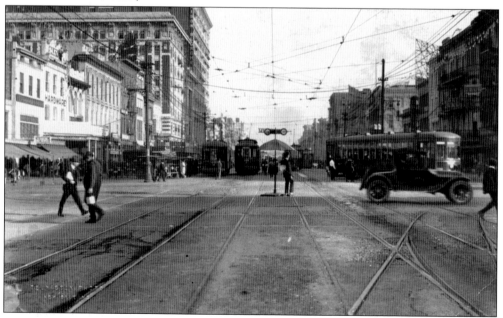

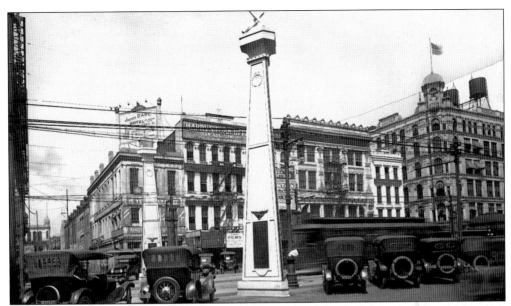

GOLD STAR. This street-level view shows the other side of the Godchaux building (right, with flag flying). Note the angle-parked cars up against the neutral ground—Canal Street really was that wide. A single-truck car heading inbound has just past the Gold Star family monuments, just behind a Perley Thomas car. On the left, you can see down Exchange Alley to the courthouse building. (Courtesy Earl K. Long Library, University of New Orleans.)

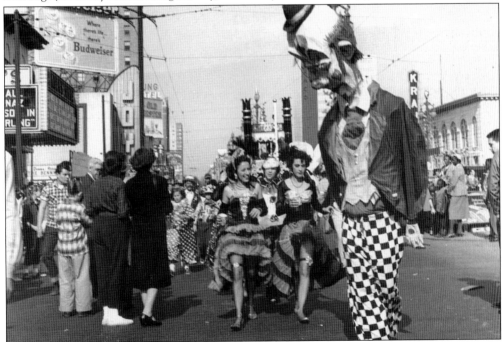

CARNIVAL PAGENTRY. Two costumed women and a clown with a giant papier-mâché head precede a riverboat float in a Carnival parade. The parade is passing Rampart street here, so it is one of the "downtown" parades that originate at the end of Canal Street, as opposed to the "uptown" parades that start on St. Charles Avenue. (Courtesy New Orleans Public Library)

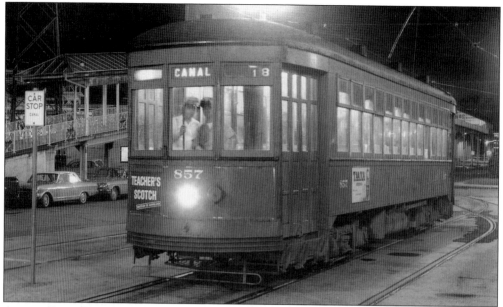

**AT THE FERRY LANDING.** The operator and conductor of car 857 pose for a photo at the ferry landing. They have made the loop around the Liberty Monument and are preparing for the lakebound leg of the route. About half of the 800-series was built by Perley Thomas, the other half by Brill to Thomas' specifications. (Courtesy of New Orleans Public Library.)

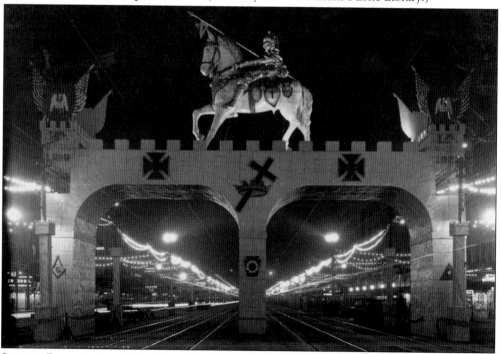

**SPECIAL DECORATIONS.** Canal Street is often seen decorated for Christmas and special events. In this 1922 photo, a double-arched bridge was constructed to welcome the 35th Triennial Conclave of the Knights Templar to the city. This arch is unusual for New Orleans because it runs over the catenary wires. (Courtesy of Louisiana State Museum.)

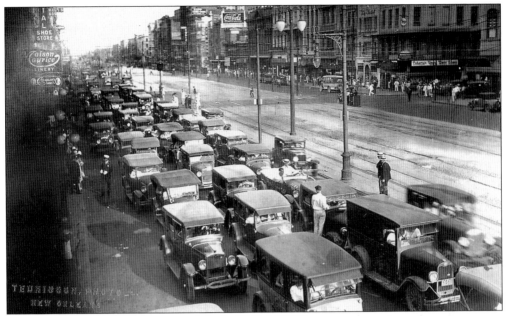

THE 1929 STRIKE. At 10 a.m. on July 1, 1929, NOPSI motormen and conductors went on strike. Two days later, it was clear that this would be a drawn-out dispute. The lack of mass transit in downtown snarled traffic on Canal. This photo was shot on July 3, 1929, showing automobile traffic stacked up heading lakebound. The strike was not over wages or hours, but rather workers' rights. (Courtesy Earl K. Long Library, University of New Orleans.)

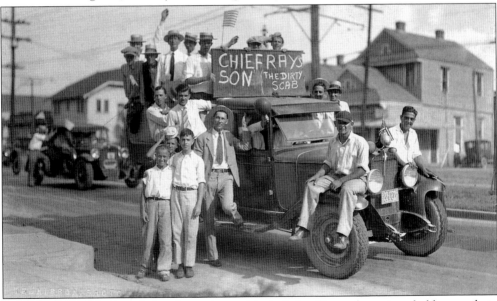

THE "PO-BOY." Unidentified strikers, along with their families and supports, held a parade in the neighborhood of Canal Station on July 7 to bolster support. The legendary New Orleans sandwich, the "po-boy," was invented during the 1929 strike. To support the strikers, a local bakery made sandwiches of French fries and roast beef gravy on loaves of French bread. Since the sandwiches didn't have any meat, even a "poor boy" striker could afford them. (Courtesy Earl K. Long Library, University of New Orleans.)

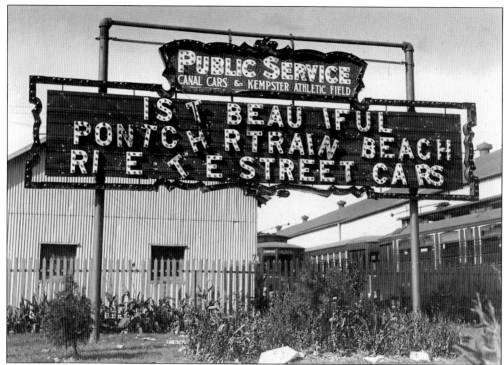

**STRIKE DAMAGE.** The strike of 1929 was a violent one, with strikers and out-of-town labor agitators causing thousands of dollars of damage. On July 5, one of the electric signs at Canal Station (Canal and North Dupre Streets) was damaged by rock-throwing strikers. A number of the streetcars on the storage tracks next to the barn were damaged as well as the sign. (Courtesy Earl K. Long Library, University of New Orleans.)

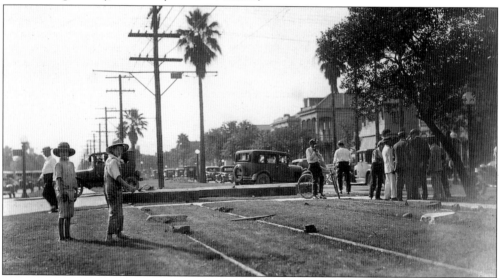

**OBSTRUCTIONS.** On July 3, strikers blocked the tracks at Canal and White Streets (one block before Canal Station) with timbers and pieces of concrete. Incidents like this happened all across the city, but particularly near the car barns; blocking the track by a barn would slow down entire lines. (Courtesy Earl K. Long Library, University of New Orleans.)

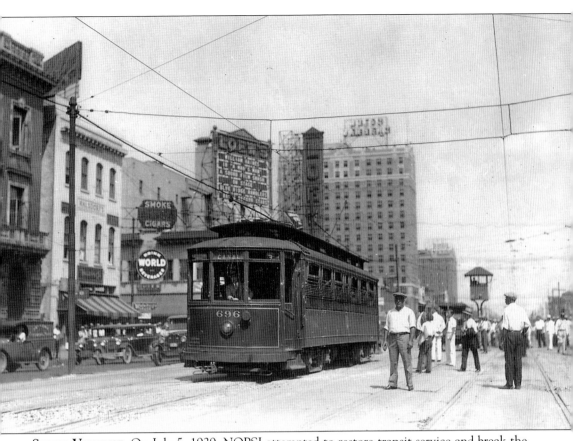

**STRIKE VIOLENCE.** On July 5, 1929, NOPSI attempted to restore transit service and break the strike. "Palace" car 696 made several early-morning runs along the line. On a mid-morning run, the car was followed down the street by groups of strikers and other agitators. About an hour after this photo was shot at Canal Street and University Place, 696 finished its riverbound run and parked at the terminal at the foot of Canal. A mob formed around the car at this point, and soon they were rocking the car back and forth on the tracks. Mounted officers of the New Orleans Police, as well as federal marshals, were unable to disperse the mob. Car 696 was turned over on its side, and the wood seats inside were set on fire. The crowd dispersed shortly thereafter; the severely damaged streetcar was recovered that evening and towed back to the barn. (Courtesy Earl K. Long Library, University of New Orleans.)

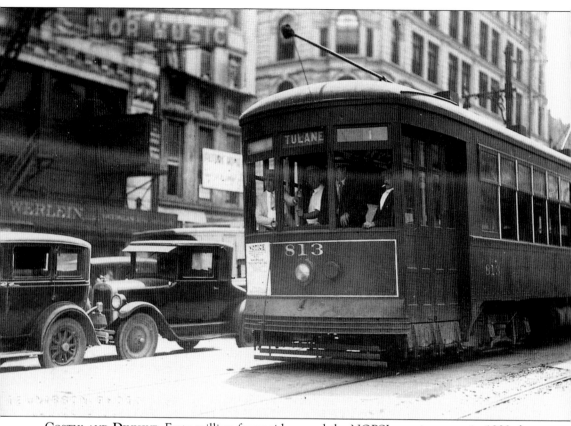

**COSTLY AND DIVISIVE.** Forty million fewer riders used the NOPSI transit system in 1929 than in 1928, a clear consequence of the strike's violent outbursts. Even though the strike was not officially ended until October 10, the union agreed to return to work in August. Brill-built Perley Thomas car 813, the first streetcar since 696 was burned, appeared on Canal on August 15, looping around on the Tulane Belt line. Car 813 completed its run successfully, and full service was restored by the next day. Car 813 is passing the Werlein's music store, which is now the Palace Café restaurant. (Courtesy Earl K. Long Library, University of New Orleans.)

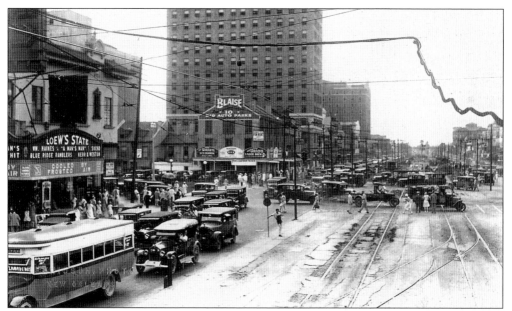

CANAL BEAUTIFICATION. In 1930, the city council approved a "beautification" project for Canal Street. All of the Canal trackage in the Central Business District was re-laid. This "before" shot from the 1929 strike shows why the project was approved. The neutral ground was cracked. Track was aging, and in some areas unnecessary, and the electric poles made Canal Street look too unattractive. (Courtesy Earl K. Long Library, University of New Orleans.)

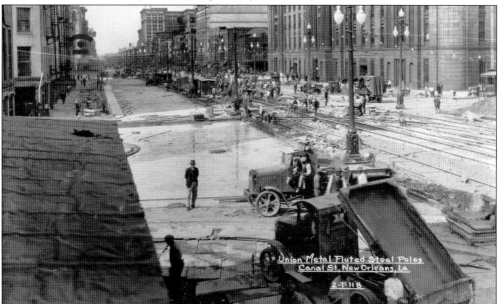

TERMINAL REDESIGN. The terminus at the Liberty Monument was reduced to four tracks. The eight-track terminal layout had been designed by Ford, Bacon & Davis. During the "golden age," streetcars from 20 different lines could be seen at this terminal point. Consolidation and re-organization of the transit lines and companies made the eight-track configuration unnecessary. The four-track configuration remained in place until 1964. (Courtesy New Orleans Public Library.)

57

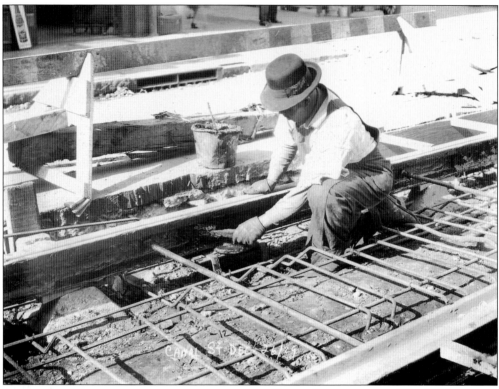

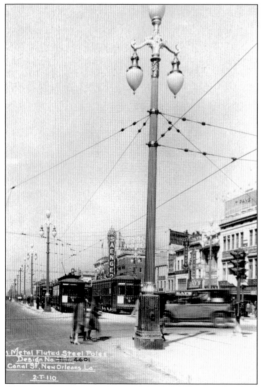

**TRACK CONSTRUCTION.** The 1930 beautification project actually began the previous winter, as this photo from December 26, 1929 shows. An unidentified worker is verifying the position of a section of rail before concrete is poured. Note the "catch basin" intake just above and to the left of his head. Intakes such as this are important to prevent street flooding on Canal Street, since New Orleans is four feet below sea level. (Courtesy Earl K. Long Library, University of New Orleans.)

**UNION METAL COMPANY.** Once the track and street surface were restored, Union Metal Company installed steel light poles along the CBD portion of Canal Street. These poles supported the overhead wires for the four-track operations across the neutral ground. The poles still adorn the CBD section of Canal Street, although the wires for the new streetcars will be suspended from poles running down the center of the neutral ground. (Courtesy New Orleans Public Library.)

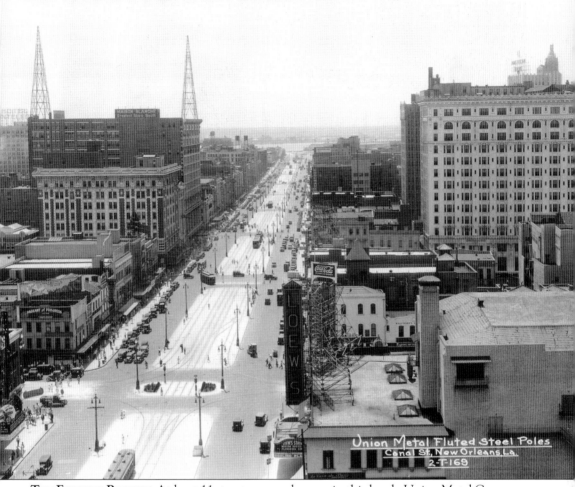

THE FINISHED PROJECT. At least 11 streetcars can be seen in this lovely Union Metal Company photo showing the completed 1930 beautification project. Shot looking toward the river from University Place, the complex turns and crossings at Rampart Street are clearly visible. In the center of the photo, a car is pulling a trailer on the inside riverbound track. Just below that, to the left of the neutral ground, a semi-convertible car is entering Canal on the outside lakebound track from Burgundy Street. In the foreground, a Perley Thomas car is heading lakebound as the four-track line has dropped to just the two inside tracks for the run to the cemeteries. (Courtesy New Orleans Public Library.)

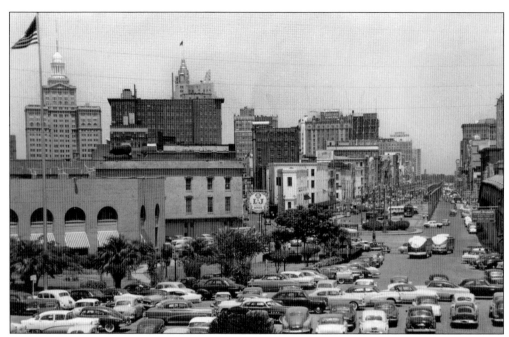

DOWN BY THE RIVER. Eads Plaza as viewed from the ferry landing. The Liberty Monument is visible a block up. The plaza was named for James B. Eads, an engineer who designed a plan to prevent silt collection at the mouth of the Mississippi River. In 1977, the plaza was renovated and a large fountain constructed; the area was re-dedicated as Spanish Plaza in 1978. After the World's Fair in 1984, the area to the left of the photo was converted into what is now the Riverwalk Marketplace shopping mall. Below is the post-1930, four-track terminal area in front of the Custom House. A Perley Thomas car waits to begin the outbound trip to the cemeteries. On the outside riverbound track, a small service vehicle is entering the loop. The white tower in the center background is the Hibernia Bank building on Carondelet Street. (Courtesy New Orleans Public Library.)

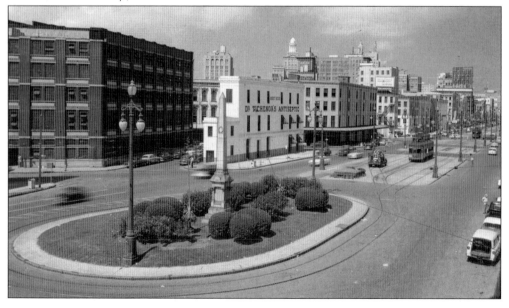

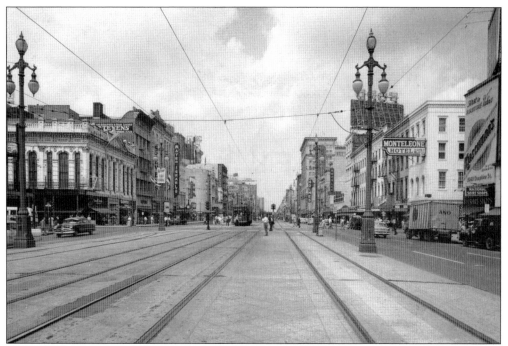

ON THE STREET. Above, another street-level shot looks toward the lake just before St. Charles Avenue. The building on the corner to the left is the Pickwick Club. The Pickwick Club is closely associated with the Mystick Krewe of Comus the oldest Carnival organization. Until a political/racial controversy in the mid-1990s, Comus would parade down St. Charles and turn the corner from St. Charles to stop right in front of the Pickwick Club, so the King could toast his queen, as well as the revelers on Canal. (Courtesy New Orleans Public Library.)

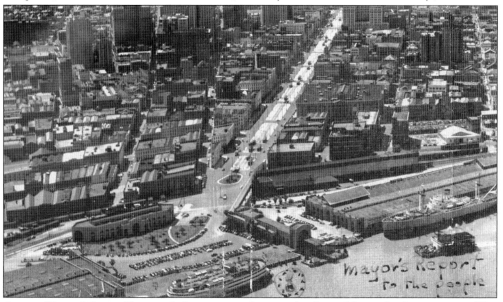

AERIAL VIEW. Liberty Place and the streetcar loop is clearly visible in the lower center. The open area to the right is Eads Plaza. The riverboat docked at the foot of Canal is the S.S. *President*, a popular tour boat of the time. (Courtesy New Orleans Public Library.)

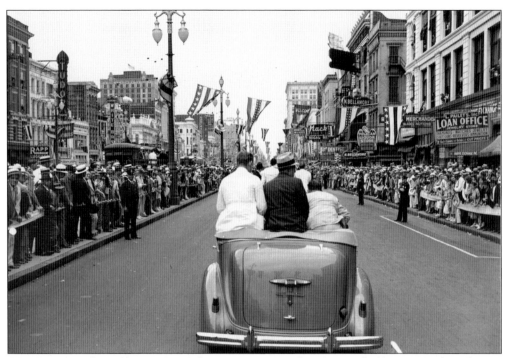

PARADES. Not all parades in New Orleans are connected to Carnival. Above, a Perley Thomas car's run to the cemeteries has been delayed while President Franklin D. Roosevelt's motorcade passes by in this pre-war visit to New Orleans. The President's car is approaching Chartres Street, where another streetcar is totally blocked from turning onto Canal. The Pickwick, the Boston, and the Chess, Checkers, and Whist Clubs are all visible in the right-center background. Below, a Pan-American parade draws a fraction of the crowd seen on Mardi Gras. Two Perley Thomas cars have paused on their way out of the CBD to let the parade go by. (Courtesy New Orleans Public Library.)

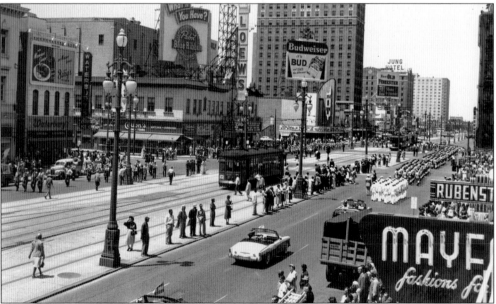

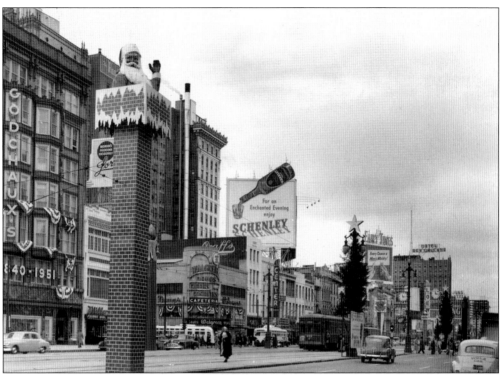

**CHRISTMAS.** Canal's width makes the street very suitable for elaborate decorations at holiday times. Both of these photos were shot looking lakebound from Carondelt Street. In the daytime shot, above, Perley Thomas car 913 is approaching Carondelet, while two trolley buses are making the turn from Canal onto Baronne Street. The blurry white spot in the left foreground of the night shot is the neon sign on the Walgreen's Drug Store at Baronne, the former location of the Chess, Checkers, and Whist Club building. (Courtesy New Orleans Public Library.)

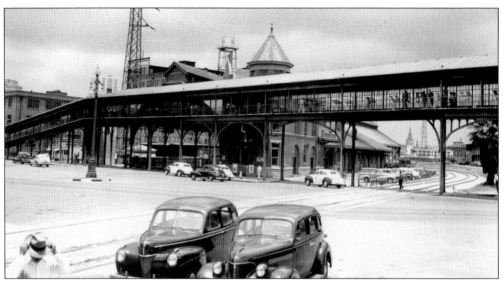

THE FERRY LANDING. The Algiers ferry connects the foot of Canal Street to Algiers on the West Bank. Since the Mississippi River at New Orleans is a deep-water ship channel, constructing a bridge over the river is a major (and costly) undertaking. Prior to the mid-1950s, the ferry was the only link to the other side of the river. Behind the elevated walkway is the Louisville and Nashville Railroad station. The spires of St. Louis Cathedral in the French Quarter can be seen in the right-hand background. (Courtesy New Orleans Public Library.)

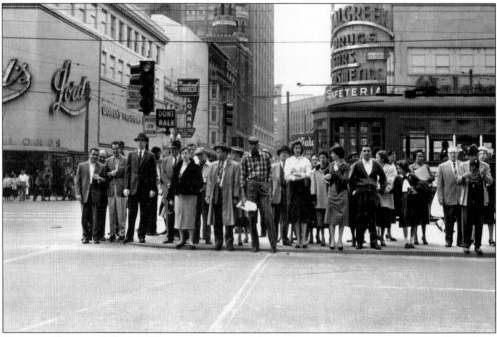

BARONNE STREET. A Perley Thomas car is stopped as pedestrians wait to cross over to Dauphine Street. The Walgreen's store, which replaced the Chess, Checkers, and Whist Club building, is in the background. The onion-domed building in the center background is the Church of the Immaculate Conception, more popularly known as Jesuit Church. Compare with an earlier shot of the corner on page 34. (Courtesy New Orleans Public Library.)

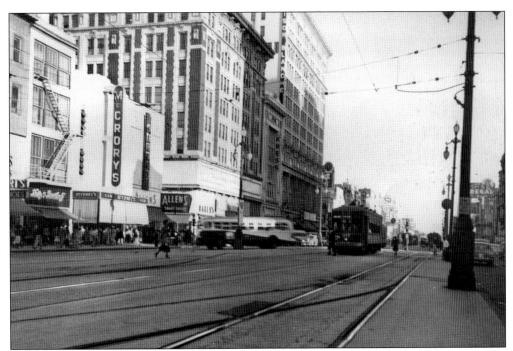

**BUSES ENCROACH.** A maroon and cream GM bus is seen turning onto Burgundy Street, heading back into the French Quarter as a Perley Thomas car rolls riverbound on the inside track. NOPSI began to phase in both diesel- and electric-powered buses throughout the post–World War II period. Below, a St. Charles line streetcar has just turned off of the outside riverbound track to head towards Lee Circle and points uptown. Even after the Canal line was discontinued in 1964, the section of the outside riverbound track from Carondelet to St. Charles has always been in service, enabling the St. Charles line to turn around and return back uptown. (Courtesy New Orleans Public Library.)

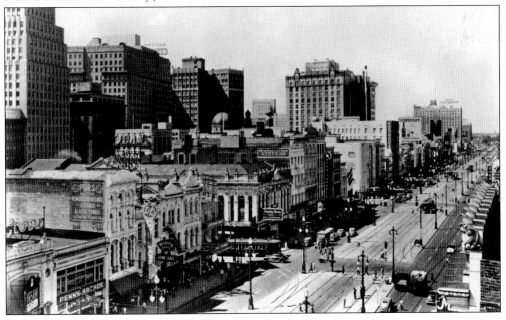

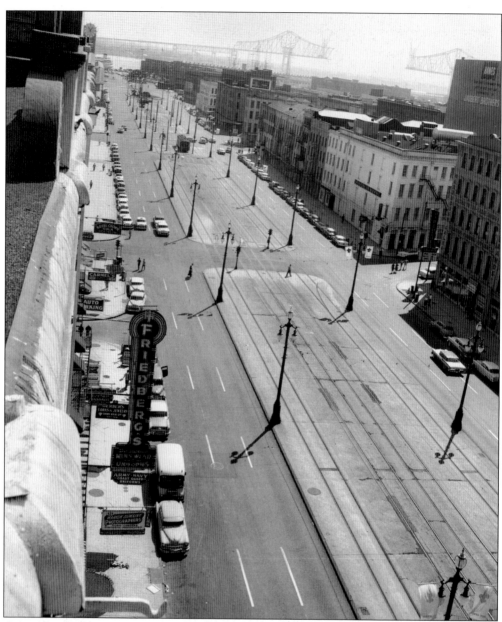

**QUIET SUNDAY.** Sunday mornings are usually quiet times on Canal Street. Lodged in between weekend shopping on Saturday and "Bargain Day" on Monday, businesses were forced to close because of Louisiana's "blue law" prohibiting store openings on Sundays. The first span of the Crescent City Connection is nearing completion in the background. The bridge, elevated 150 feet above the river, was the first bridge across the river constructed in the history of the city. Prior to its completion in 1958, the only way to cross the river was to use one of the three ferries (Chalmette, Canal-Algiers, Jackson-Gretna) in operation. This photo was taken in 1957, just prior to the major construction work started in the winter of that year. By this time, the only two streetcar lines remaining in New Orleans ran on Canal Street and St. Charles Avenue. The city government determined that the outside tracks on Canal Street would no longer be needed, so the decision was made to rip them up. (Courtesy New Orleans Public Library.)

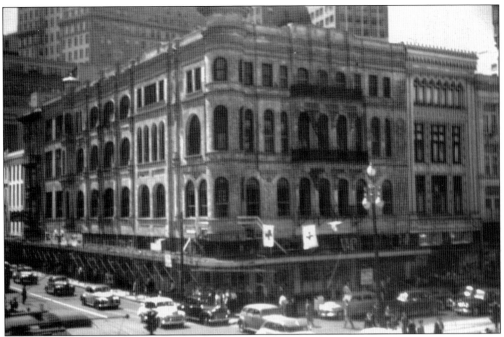

**CARONDELET STREET.** Feibelman's Department store operated at this location on the corner of Canal and Carondelet until 1931. The company became affiliated with Sears, Roebuck in 1930. Feibelmen's constructed a new store a block away on Baronne and Common, which became the downtown Sears store for decades. This Dorothy Violet Gulledge slide shows the building before it was demolished in 1949 and the Gus Mayer department store was constructed in its place. (Courtesy New Orleans Public Library.)

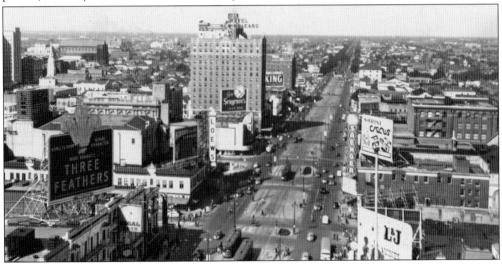

**LEAVING THE CBD.** Looking towards Lake Pontchartrain from the Maison Blanche building, this photo shows the transition from concrete to grass in the neutral ground at Claiborne Avenue. Three Perley Thomas cars are visible, all heading riverbound. Once the Canal and West End lines passed the intersections at Rampart and Basin Streets, the line no longer connected with transit lines every block, so the cars began to pick up a bit of speed on their way to the cemeteries. (Courtesy New Orleans Public Library.)

**DESIRE.** The Desire line services the restaurants, bars, and nightclubs along Bourbon Street. Other than the turnaround on Canal, the line ran entirely on the streets of the Quarter, Faubourg Marigny and Bywater. This Perley Thomas car heading away from the CBD on Bourbon is the sort of scene that inspired Tennessee Williams's play, which made Desire the most well-known streetcar in the world. (Courtesy New Orleans Public Library.)

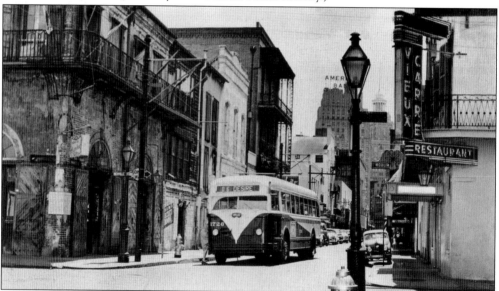

**A BUS NAMED "DESIRE?"** The lines servicing the Quarter were converted to buses in the early 1950s. Concerned with the damage the big diesel buses were doing to the historic buildings of the Quarter, NOPSI re-routed lines that needed to pass through the Quarter to either Decatur or Rampart Streets in the 1970s. To service the Quarter itself, they began operating smaller "mini-buses" designed to look like single-truck streetcars. The Brennan's Vieux Carré Restaurant located on the right side of the photo is the original location of the now-world-famous Brennan's Restaurant, located on Royal Street. (Courtesy New Orleans Public Library.)

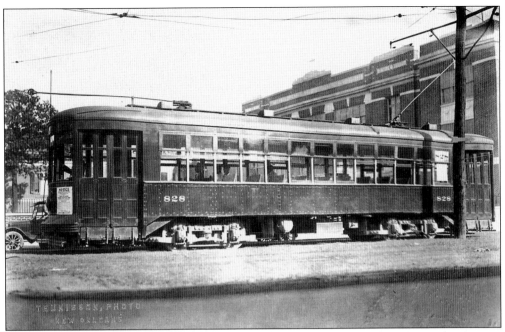

RAMPART STREET. Operating on the Canal Belt line, Perley Thomas car 828 (Brill-built) has just turned in front of St. Aloysius High School on the corner of Esplanade and North Rampart to head up Rampart to Canal Street. Many of New Orleans large streets have grassy neutral grounds; over 40 percent of NOPSI's streetcar operations were in these neutral grounds. (Courtesy Earl K. Long Library, University of New Orleans.)

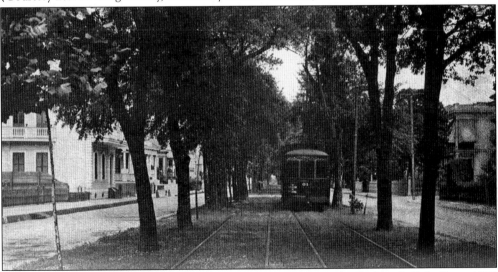

ESPLANADE AVENUE. "Palace" car 61 is seen here operating on the Esplanade Belt. From 1901 to 1934, the Esplanade Belt line ran in counterpoint to the Canal Belt. Starting at the foot of Canal, Esplanade Belt cars would turn right and go down North Rampart to Esplanade, then turn left to go up Esplanade Avenue to Bayou St. John. The cars would turn from there onto Moss Street, then to City Park Avenue, where they would journey west to the cemeteries at the end of Canal Street. Arriving at Canal, the cars would turn and head down Canal back to the river. (Courtesy New Orleans Public Library.)

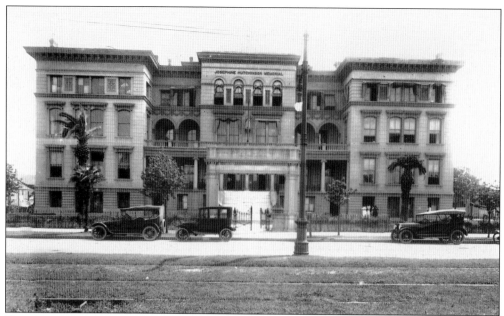

**TULANE MEDICAL SCHOOL.** The Josephine Hutchinson Memorial Building of Tulane's medical school is located at Canal and North Robertson. Just outside of the CBD, this is one of the first blocks of grassy neutral ground. Tulane sold the building in the mid-1930s and by 1938 the block was converted into a gas station and a car dealership. (Courtesy Earl K. Long Library, University of New Orleans.)

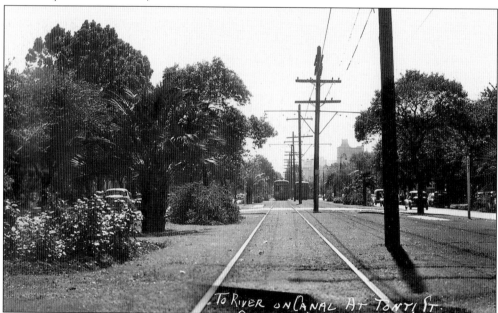

**TONTI STREET.** The office buildings of downtown can be seen in the background of this 1945 photo. Two Perley Thomas cars pass each other on the river side of Tonti Street. From Claiborne to the cemeteries, Canal Street became a sea of green, with palm trees, bushes, and flowers planted in the neutral ground. (Courtesy Earl K. Long Library, University of New Orleans.)

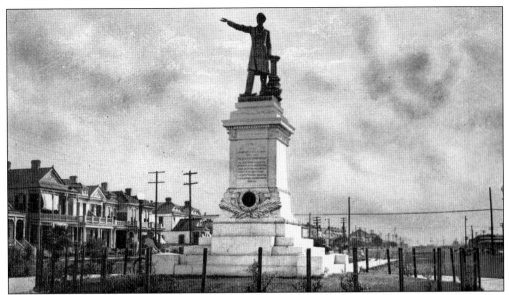

**JEFFERSON DAVIS.** At the intersection of Canal Street and Jefferson Davis Parkway stands a statue to the only President of the Confederate States of America. Construction on the statue began in 1908 and it was dedicated in 1911. Davis is on the uptown side of Canal, looking over the intersection across to First Methodist Church. Davis was a regular visitor to New Orleans and enjoyed immense personal popularity well beyond his death in 1889. Davis died while visiting friends in New Orleans and was buried temporarily at Metairie Cemetery, which is along the West End streetcar line. (Courtesy New Orleans Public Library.)

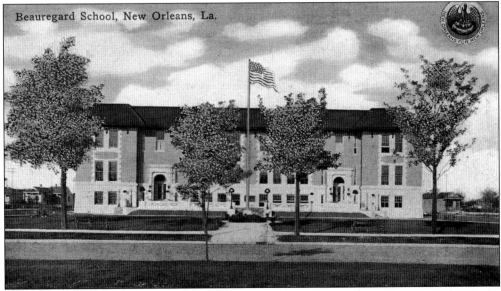

**BEAUREGARD SCHOOL.** Located at Canal and North St. Patrick and named for Confederate General P.G.T. Beauregard, this school was built in 1909. The school was renamed in 1994 to Thurgood Marshall Middle School, in honor of the first African American to serve as an associate justice of the U.S. Supreme Court. Originally an elementary school, Beauregard became a junior high (seventh, eighth, and ninth grades) in 1952. It became a middle school (sixth, seventh, and eighth grades) in 1987. (Courtesy New Orleans Public Library.)

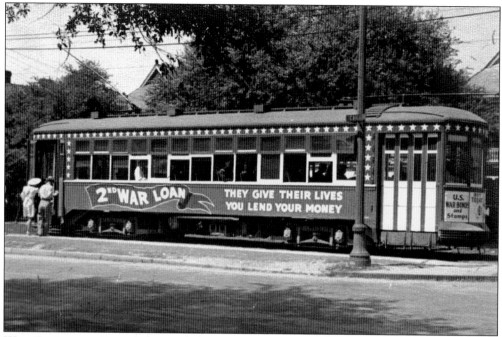

**WAR BONDS.** One of NOPSI's contributions to the war effort during World War II was to promote the sale of war bonds and stamps using streetcars. This Perley Thomas car, embellished with red, white, and blue, is picking up passengers at a corner outside the CBD, on its way to the cemeteries. In the days of two-man operation, passengers boarded at the rear, paid the conductor there, and exited at the front. (Courtesy New Orleans Public Library.)

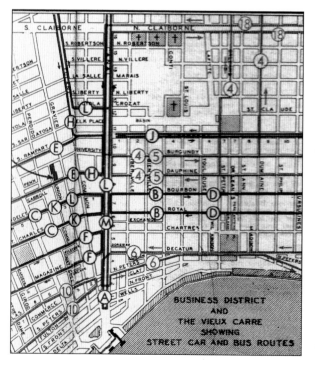

**TRANSIT MAPS.** NOPSI published maps detailing the routes of buses and streetcars in the city annually. While electric street railways were the biggest consumers of electricity at the beginning of the century, NOPSI was becoming weary of running the city's transit system by the time this map was drawn in 1946. Many lines had been converted to bus operations, and NOPSI executives regularly felt that the city government was holding them hostage—threatening to make things difficult for them if NOPSI didn't continue to maintain the transit system. On this map, streetcar lines are indicated by letters, bus lines by numbers. One bus line, Broadway, was the only trolley coach line at the time. (Courtesy New Orleans Public Library.)

**ST. ANTHONY'S.** Across the street from Marshall Middle is St. Anthony of Padua Church and School. This is the Roman Catholic parish for Mid-City and upper Lakeview. The parish was established in 1915 by Dominican priests and is still administered by that order. (Courtesy New Orleans Public Library.)

Residence, Canal Street, New Orleans, La.

**CANAL STREET HOME.** While Canal Street never rivaled the elegant mansions of St. Charles Avenue, there are still a number of lovely homes along the street outside of the business district. Many of these homes have been converted to offices for legal, medical, and accounting practices, or other purposes, such as the Ronald McDonald house. (Courtesy New Orleans Public Library.)

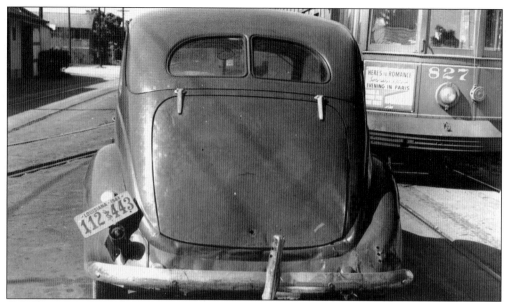

CITY PARK AVENUE. An automobile that was involved in a fatal accident is parked at the NOPD station. Brill-built car 827, running on the West End line, has turned off of Canal at the cemeteries and is now moving westbound on City Park Avenue. The car will go another block and turn in front of the Halfway House, a nightclub at 102 City Park Avenue. The club got its name because it is roughly half the way between downtown and West End. The streetcars turn right here, heading north along the New Basin Canal to the lake. (Courtesy New Orleans Public Library.)

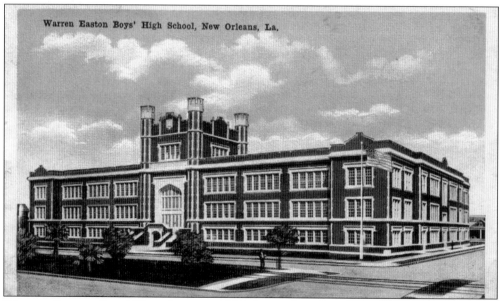

WARREN EASTON BOYS' HIGH SCHOOL, 1910. Located on Canal, between North Lopez and North Salcedo, Warren Easton is now a co-ed, "fundamental" high school with grades 9 through 12. The original NOCRR/NOPSI car barn was separated from the school by a baseball stadium (Kempster Athletic Field). The field was absorbed into the car/bus barn complex, so now the school and RTA are neighbors.

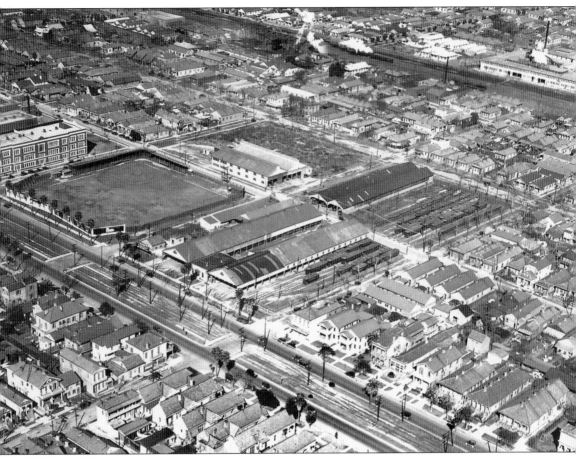

**CANAL STATION.** This 1927 photo shows the neighborhood around Canal Station. The baseball field between the car barn and Warren Easton High School is Kempster Athletic Field. This land was subsequently acquired by NOPSI for use as a bus parking lot. The barn and storage facilities extended from Canal Street, crossed Iberville Street, and ran to Bienville Street. The Canal Shops are the buildings in the block from Iberville to Bienville, as well as the buildings behind the baseball field. This is where the Morris Cars were constructed. Note the mixture of single-truck, semi-convertible, and arch roof cars in the storage area. The railroad tracks in the background belong to Southern Railways; this is how Southern trains heading into their downtown station at Canal and North Rampart accessed downtown. (Courtesy Earl K. Long Library, University of New Orleans.)

**CANAL STATION.** Constructed by the New Orleans City Railway Company in 1861, the Canal barn was originally built for horsecars. It was modified in 1887 to accommodate a larger volume of streetcars. It was again modified in the 1890s for electrification. This photo, from the late 1950s, shows the tracks leading into an open storage area in the foreground, and the entrance of Building #2. Building #1 is next, which has been converted for servicing buses. Following that is the open bus lot (the site of the current Randolph SIS facility), then Warren Easton High School in the background. (Courtesy New Orleans Public Library.)

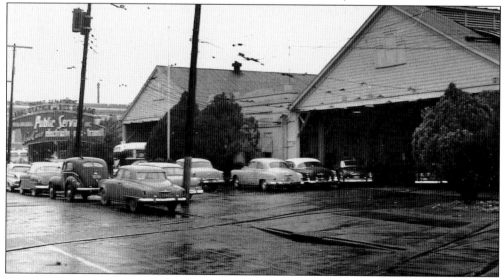

**PASSING CANAL STATION.** Buses dominated the barn area in this 1957 photo. By this time, Canal was the only streetcar line being serviced here. One of the familiar maroon-and-cream colored GM buses can be seen pulling out of Building #1 onto Canal. (Courtesy Earl K. Long Library, University of New Orleans.)

OL. I—No. 1       Published Weekly by N. O. Public Service Inc.       SEPT. 15, 1947

# NOPSI To Sponsor "Information Please" Over WNOE Every Friday, Starting Sept. 26

"Information Please"—the quiz show that sparkles with wit and wisdom—will be brought to you this year by New Orleans Public Service.  Starting on Friday night, September 26, and every Friday thereafter, the Mutual Broadcasting System and WNOE will present Messrs. Clifton Fadiman, John Kieran, Franklin P. Adams and their guest-guessers under NOPSI sponsorship.

You'll enjoy Fadiman's smooth questioning of the experts and the clever answers of Kieran, sports authority, bird and nature expert, Shakespearian enthusiast and Latin scholar, and Adams, eminent columnist and punster par excellence.

Fred Allen, radio comedian, and Robert Montgomery, movie star, will be the guests for the 1947-48 opener on September 26.  The time of the broadcast will be 7:30 P. M. and the station is WNOE—1450 on your dial.  After the opening program, "Information Please" will be heard each Friday at 8:30 P. M., because of the change from daylight to standard time in the East.

## Trolley Coaches Start on Jackson Line About Oct. 1

Trolley coaches — inaugurated on the first line on September 4 with celebra-

## Frnka Working Greenies Hard For Alabama Game

Sizzling weather and baseball play-offs to the contrary, it's almost football time in Dixie and Coach

RIDER'S DIGEST. This is volume one, number one of NOPSI's *Rider's Digest* publication. The *Digest* was a small, folded newsletter whose stories included transit news, safety tips, NOPSI happenings, sports news (mostly Tulane and LSU stories), and even recipes. Note the article, bottom left, on trolley coaches. The use of "trackless trolleys" on the Broadway line uptown had been a success, so the company ordered additional trolley coaches and began to use them instead of streetcars. NOPSI published the *Digest* until the 1980s. (Courtesy New Orleans Public Library.)

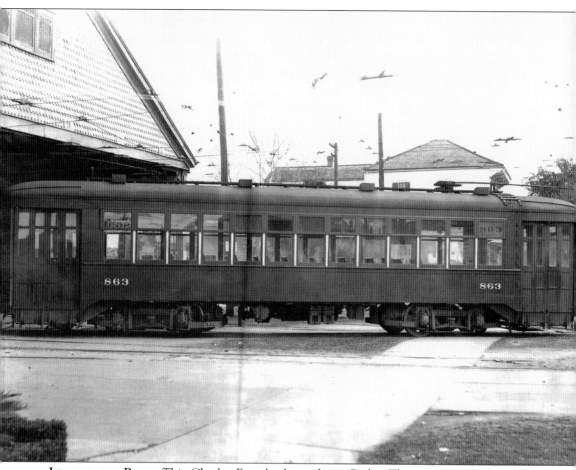

**LEAVING THE BARN.** This Charles Franck photo shows Perley Thomas car 863 (Brill-built) leaving Canal Station in 1927. The main distinguishing feature between the 800-series (Brill) and 900-series (Perley Thomas) cars is that the Brills had manual doors, while the Perley Thomas-built cars had pneumatic doors. Otherwise, the cars were almost identical. The four appendages on the roof are ventilators to facilitate air circulation. The wood seats are of the "walk-over" variety. When the cars change direction, the rider can pull on the back of the seat and it will change direction. While cars were serviced and painted at Canal Station, no major construction took place here after 1910. (Courtesy Earl K. Long Library, University of New Orleans.)

# Four

# DECLINE AND DISCONTINUANCE 1957–1964

New Orleans Public Service, Incorporated, discontinued the West End line on January 15, 1950, leaving the Canal line as the only one using the inside pair of tracks in the Central Business District. Almost a year later, the St. Charles line was converted back from Belt operation to two-way operation. This closed the Tulane Belt line as well. Two years later, on January 5, 1953, the South Claiborne line was discontinued, followed by the Napoleon line on February 18, 1953. From this point until May 31, 1964, the only two streetcar lines in New Orleans were the Canal and St. Charles lines. New Orleans had gone from being one of the most active and innovative street railway cities to having next to nothing. New Orleans Public Service, Incorporated considered streetcars to be a thing of the past, regularly arguing that streetcar maintenance was cutting into profits. The best way to keep fares down, they said, was to motorize streetcar lines. City government was not particularly interested in operating the transit system, so the concerns of streetcar advocates fell upon deaf ears. New Orleans Public Service, Incorporated wanted buses; the city did not want the stress of mass transit, so New Orleans Public Service, Incorporated got their buses. Mayor "Chep" Morrison's vision of New Orleans was one of a port city, a gateway to Central and South America. While the charm of the French Quarter was indisputable, promoting tourism was not one of his priorities. Promoting the city as a business hub meant having a modern, up-to-date downtown, not one with "charm."

The city government authorized the first major overhaul of the street since the 1930 beautification project. Four-track operations disappeared from Canal Street, in spite of unparalleled growth of the downtown area. The turnaround at Liberty Place remained until the Canal line was discontinued. Besides the terminal tracks at the foot of Canal Street, the only track other than the two center tracks was the one-block turnaround track for the St. Charles line.

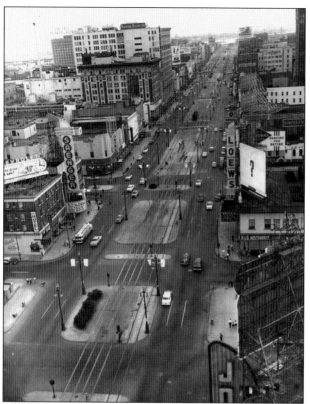

**BEFORE THE RENOVATION.** These photos were shot within minutes of each other, as the billboard clock above the Saenger Theater can attest. They are part of a series of "before" photos shot in October of 1957. The light traffic of a Sunday afternoon was a good time for the photographer to capture the complex trackage between Burgundy and Basin Streets. The photo at the right appears to have been shot from one of the upper floors of the Jung Hotel, looking towards the river. Below, the photographer came down to street level minutes after the previous photo. Note the trolley wires in the auto lanes on either side of the neutral ground. These are for the trackless trolleys running on the St. Claude (left) and Tulane (right) lines. The Perley Thomas car at Burgundy in the top photo is barely visible on the lakebound track at bottom.

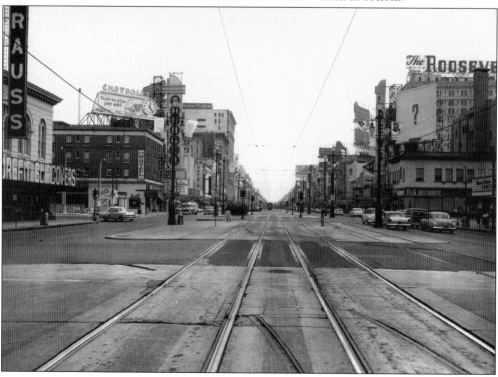

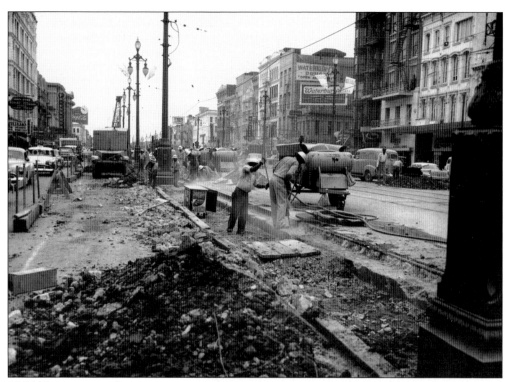

**1957 Renovation.** Starting in late 1957, the outside two tracks on Canal were ripped up and replaced with flowerboxes spaced along the street. Above is a close-up of the construction work. Looking from Camp Street towards the river, workers have blocked off the auto lane closest to the neutral ground as staging area. Note the Godchaux building just visible on the left and Waterbury's Drugstore, a local institution, on the right. The view at right shows Canal, from Rampart to the river. The Perley Thomas cars are still in operation on the inside tracks, and buses prowl the auto lanes. The riverboat S.S. *President* is visible in the background, docked on the river at Canal. (Courtesy of New Orleans Public Library.)

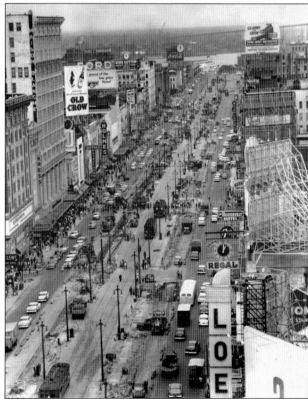

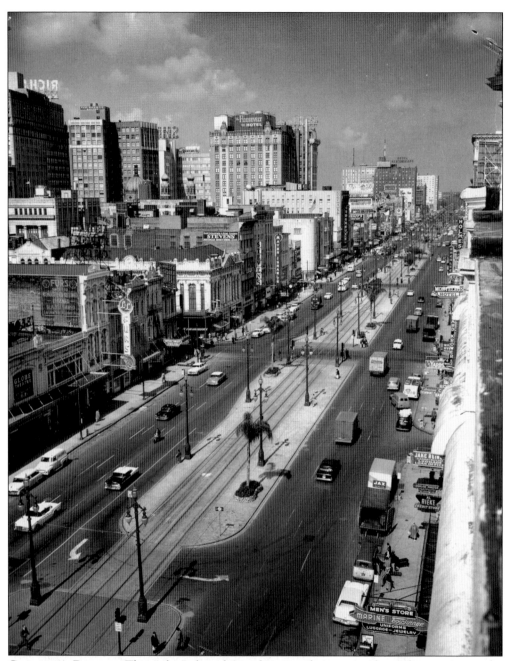

COMPLETED PROJECT. This "after" shot shows that just the two inside tracks remain on the neutral ground. Palm trees have been planted in irregular-shaped boxes of cobblestones along the line. This photo, from the spring of 1958, was shot from the Godchaux building, looking lakebound. The site is currently occupied by the Marriott Hotel. The white façade of the Pickwick Club can be seen just left of center. This photo was obviously also shot on a Sunday; there is only one streetcar visible, in the background. Canal Street was usually packed with streetcars, right up until the line was discontinued, but Sunday mornings were truly dead times downtown. (Courtesy of New Orleans Public Library.)

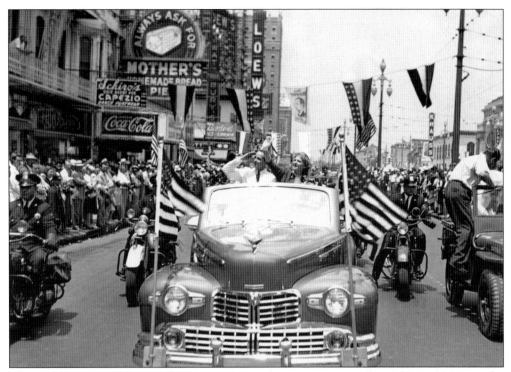

**"Chep" Morrison.** deLesseps S. "Chep" Morrison's tenure as mayor, from 1946 to 1961, saw the greatest decline in New Orleans' streetcar system. Here, Morrison and his wife ride riverbound on Canal during his first inauguration parade in 1946.

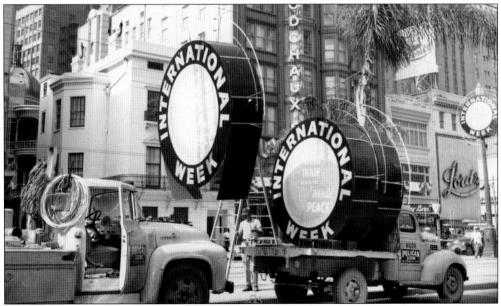

**Decorations.** City Hall sponsored a number of events promoting New Orleans's various relationships and partnerships with the rest of the world. Morrison promoted the city so heavily in Latin America that it came to the attention of President Kennedy in 1961, and he appointed Morrison to be the Ambassador to the Organization of American States (OAS).

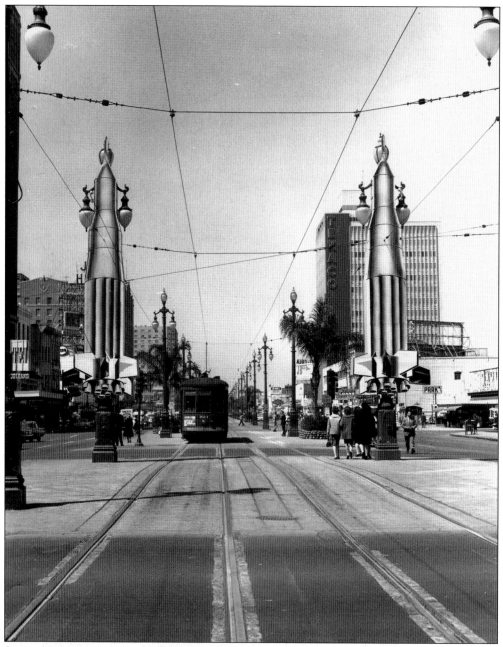

**SPACE AGE!** New Orleans shared in the economic boom of the space program in the early 1960s when NASA took over an old tank factory in Eastern New Orleans and converted it into a construction facility for the Saturn V, 1B, and 1C rocket boosters. To celebrate the city's new involvement in the space race, these rocket decorations adorned Canal and Basin in 1961. An 800-series car is heading riverbound.

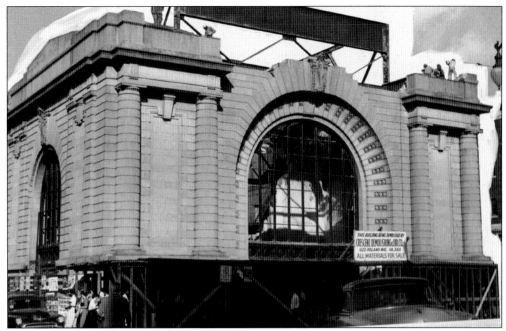

**CHANGING TRAINS.** The 1950s saw dramatic changes in passenger train service in New Orleans as well as street railway service. When the city merged all passenger service coming into the city into the new Union Passenger Terminal in 1954, the passenger stations run by the individual railroads were no longer needed. Above, the Southern Railway terminal is shown in 1956, during the middle of demolition. The demolition was a far cry from the station's heyday (page 38). Below, this aerial view of the foot of Canal shows the empty space by the ferry landing where the L&N Railroad station was located. This station was also demolished after the new terminal became operational.

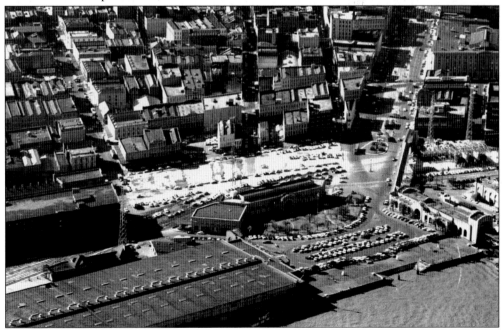

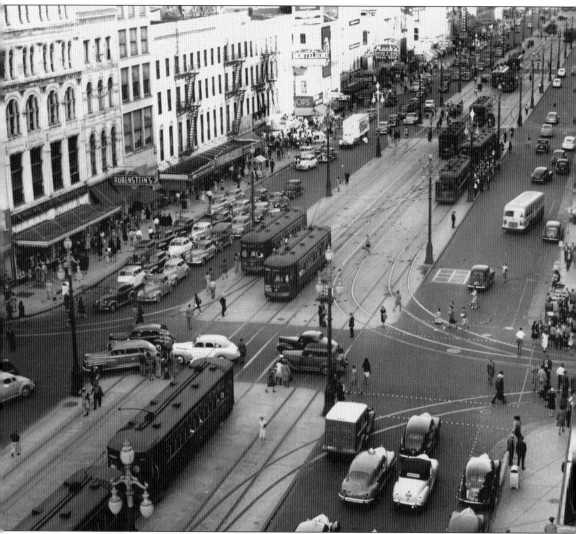

**Busy Afternoon.** The corner of Canal and Carondelet is hectic one afternoon in 1948. All streetcar lines ran Perley-Thomas cars by this time. The cars on the inside tracks would be Canal and West End line cars, and the outer tracks would be all the side-street lines that make their way to Canal. The post-war period marked a serious decline in streetcar operations. NOPSI would have dropped many lines earlier, but the federal government would not allow streetcar lines to be discontinued during the war. Heavy rush-hour traffic, "old looks" buses, and pedestrians clog the street.

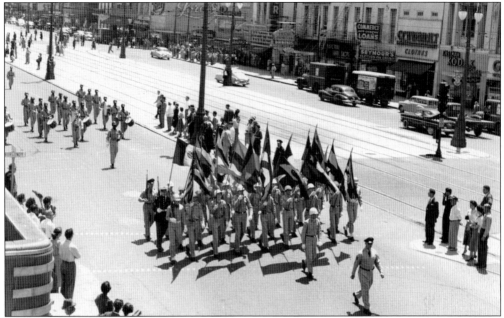

MILITARY PARADES. It's just not the same as a Carnival parade, as the light crowd for this military parade illustrates. It is unclear if it is just coincidence that there are no streetcars in the two blocks captured by this photo, or if streetcar service had been suspended during the parade. (Courtesy of New Orleans Public Library.)

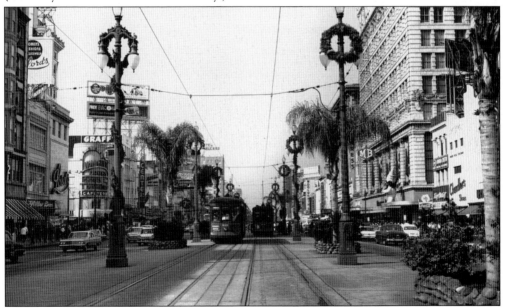

CHRISTMAS. Wreaths and garland adorn the Union Metal Company light poles in this 1959 photo. This shot is from Canal and Bourbon, with the photographer standing in the middle of the neutral ground. A lakebound car has just passed on the right and a riverbound car is approaching on the left. If you look carefully on the right, you can see "Mr. Bingle," the Christmas mascot of the Maison Blanche department store, outside the store's entrance. (Courtesy of New Orleans Public Library.)

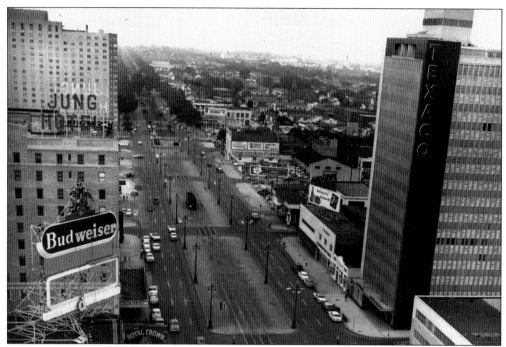

**LOOKING LAKEBOUND.** This is another in the "after renovation" set from 1958. Looking lakebound from Basin Street, the Jung Hotel and the Texaco building frame Canal Street as a Perley Thomas car makes its way to the river. The transition from grassy neutral ground to concrete is clear in this photo. (Courtesy of New Orleans Public Library.)

**PAN AMERICAN LIFE.** Constructed in 1950, this building housed one of the city's largest employers, Pan American Life Insurance Company, until the company built a new office tower on the corner of St. Charles Avenue and Poydras Street in 1976. As such, Pan American is one of the few companies in town to be on both of the major streetcar lines. This building, located in the block between South Tonti and South Rocheblave Streets, was one of the few above Claiborne Avenue that was higher than two stories. (Courtesy of New Orleans Public Library.)

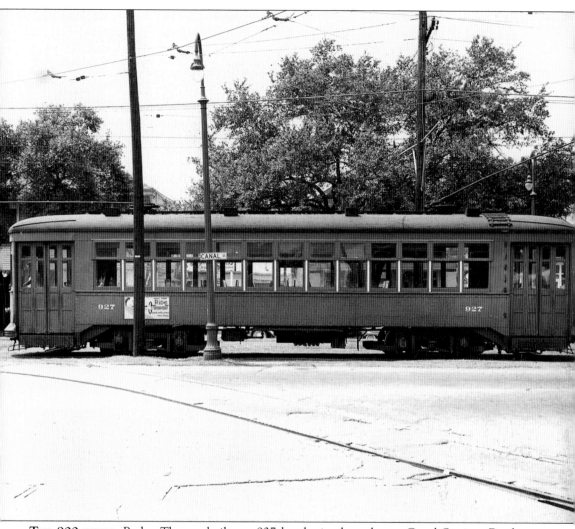

**THE 900-SERIES.** Perley Thomas-built car 927 heads riverbound near Canal Station. By the early 1960s, the Canal streetcars had lost a great deal of their charm. The ride was hot and bumpy compared to air-conditioned buses servicing other parts of the city. Additionally, riders going out to Lakeview had to get off the streetcars at the cemeteries and transfer to other lines. NOPSI capitalized on this rider dissatisfaction to lobby the city government to discontinue both of the remaining streetcar lines, St. Charles and Canal. (Courtesy Earl K. Long Library, University of New Orleans.)

**CARNIVAL DECORATIONS.** City workers mount decorations for Carnival on the Union Metal steel poles near Claiborne Avenue. The city still decorates the poles for various occasions, but using banners that are all a standard size. That way, one set of banners can be easily taken down from the poles to quickly make room for the next event or holiday. (Courtesy of New Orleans Public Library.)

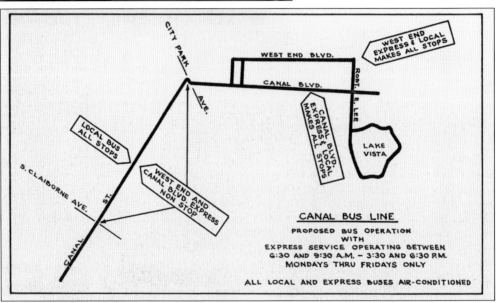

**BUS PROPOSAL.** This sketch of the Canal line shows the proposed changes to the route which would take place when streetcars were discontinued and bus service on Canal initiated. The most attractive aspect of this proposal to the riding public was the introduction of direct bus service to the Lake Vista and Lakeshore neighborhoods. Passengers were sold on the idea of riding air-conditioned buses from the CBD all the way home, rather than hot, old streetcars to City Park Avenue, then transferring to buses for the rest of the trip. (Courtesy of New Orleans Public Library.)

SNOW! Snowfall can paralyze New Orleans in a very short time. The city has no infrastructure for dealing with snow and/or freezing rain, so streets become cold, wet, and slippery. Traffic backs up, and trips that might only take 15 minutes can take two hours. That was the story on December 31, 1963, as everyone tried to make his or her way home from downtown. Ice and snow on the Mississippi River Bridge caused traffic to stack up on the Pontchartrain Expressway, so that caused a back up on the Canal ferry. A trolley bus turns from Camp for its one-block appearance on Canal. Even though the Canal line had less than six months' life, service never dropped off. Four Perley Thomas cars are slowly making their way to the Liberty Monument, while two others are waiting for an 18-wheeler to clear the intersection so they can continue riverbound. Two cars are at the terminal at the foot of Canal, very close to the white-dusted ferry landing in the background. (Courtesy of New Orleans Public Library.)

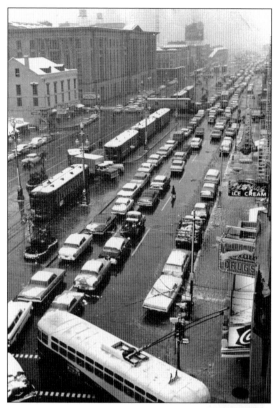

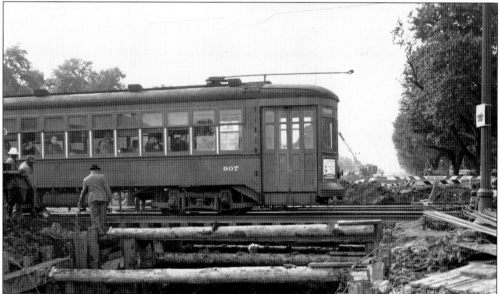

CONSTRUCTION CAUTION. A motorman carefully inches Perley Thomas car 807 across a Sewerage and Water Board excavation at Canal and Jefferson Davis Parkway. This construction was part of a 1960–1961 project by the S&WB to install a ten-foot square covered concrete canal under the Jeff Davis neutral ground. Flood control and drainage projects receive high priority in a city that is mostly below sea level. (Courtesy of New Orleans Public Library.)

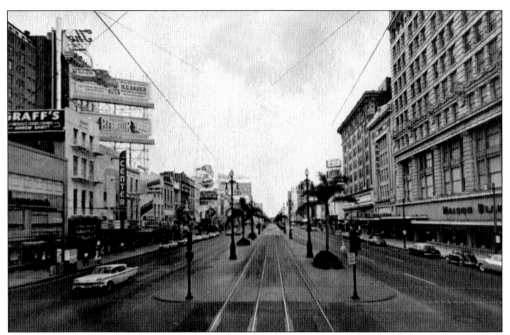

**DISCONTINUING STREETCARS.** Two photos from a 1960 proposal by NOPSI to the city (and just about anybody else who would listen) show the company's plan for removing streetcars from Canal. Above is the "before" photo, showing the tracks and overheard wires. The "after" photo below shows the wires and tracks airbrushed out. In their place a "bus zone" has been created. This zone would allow buses to run the length of the street without disrupting auto traffic. NOPSI's original plan to scrap both the Canal and St. Charles lines had met with very stiff opposition. To salvage something from the situation, the company agreed to make improvements on the St. Charles line and its cars if this proposal for Canal Street was accepted.

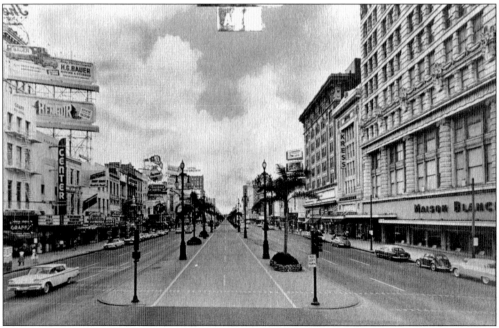

**PCC CARS.** New Orleans had never acquired the President's Conference Committee (PCC) cars that were quite popular in other cities in the United States. NOPSI preferred to continue the use of the double-ended Perley Thomas cars rather than switch to the single-ended PCC cars. To counter the possible argument that PCC cars could be used on Canal Street, NOPSI included a section in their 1960 proposal explaining why PCC cars wouldn't work on Canal. Above, the proposal included a series of small maps showing the trackage that would have to be added to the Canal line to accommodate single-ended cars. PCC cars have only one trolley pole, so they require turnaround and wye tracks to reverse direction, as opposed to the double-ended conventional cars where you just pull down one trolley pole and release the other. The proposal also included the photo, above, of Baltimore Transit PCC car 7098.

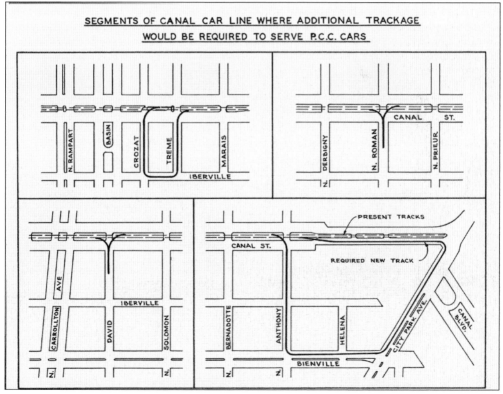

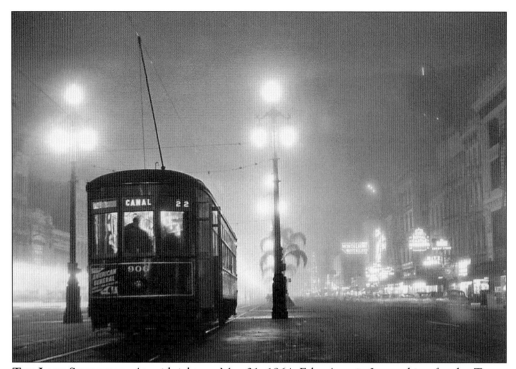

**THE LAST STREETCAR.** At midnight on May 31, 1964, Erby Aucoin Jr., working for the *Times-Picayune* newspaper, captured car 906 as the car made one of the last runs on the line. Thirty-five of the Perley Thomas cars were kept for St. Charles operations, all in the 900 series. The remainder of the 900 series, save for two sold to museums, were scrapped. All of the 800 series were scrapped as well, except for a handful of cars that were sold to museums. The city's compromise with NOPSI was complete. NOPSI would continue the St. Charles line, but at Canal's expense. Preservationists still didn't trust NOPSI, and in 1971 placed on the National Register of Historic Places. This designation protected the remaining streetcars and the line itself. Still, the deal meant that almost a century of history and memories would vanish almost overnight as the cars were scrapped and the tracks on Canal were dismantled. Mr. Aucoin's photo, listed in 1999 as one of the top 100 photos of the 20th century in New Orleans, appropriately shows the Canal line vanishing into the mist that is history. (Courtesy Erby Aucoin III.)

# Five

# BUSES ON CANAL
# 1964–2003

*The last revenue run of the Canal line left the foot of Canal Street just after midnight on the evening of May 30, 1964. Car 958 made its way down to the cemeteries, taking on passengers at City Park Avenue. The car was already filled with streetcar activists and others wanting to say good-bye. After a number of delays, 958 arrived at Canal Station, where the riders were met by an official delegation led by Mayor Victor H. Schiro. Protesters threw hot dogs at him, calling him a "weenie" for abandoning the streetcars.*

*After being welcomed by the mayor, the riders were switched to car 972, which had banners on the sides that said "See Me On St. Charles." Car 958 turned into the barn and the last revenue run on Canal Street was complete. When 972 reached St. Charles, the riders exited, the car was switched to the outside riverbound track, and it turned onto St. Charles Avenue. A century of streetcars on Canal Street came to an end.*

*New Orleans Public Service, Incorporated had a fleet of General Motors "new looks" buses ready to roll for Canal Street from midnight the previous evening. The streetcar was replaced by the Canal-Cemeteries bus line and two new lines were added. The old West End line was resurrected in the form of the Canal-Lakeshore line, which ran up Canal Street, turned left on City Park Avenue, then out to the lake via Pontchartrain and West End Boulevards. The Canal-Lake Vista line went up Canal Street, turned right-then-left at City Park Avenue, and continued lake-bound on Canal Boulevard. The line wound its way along Marconi and Lakeshore Drives, terminating at Spanish Fort. Two more "express" lines were inaugurated on May 31, 1964, following the Lakeshore and Lake Vista lines. The express lines did not stop on Canal Street from Claiborne to the cemeteries.*

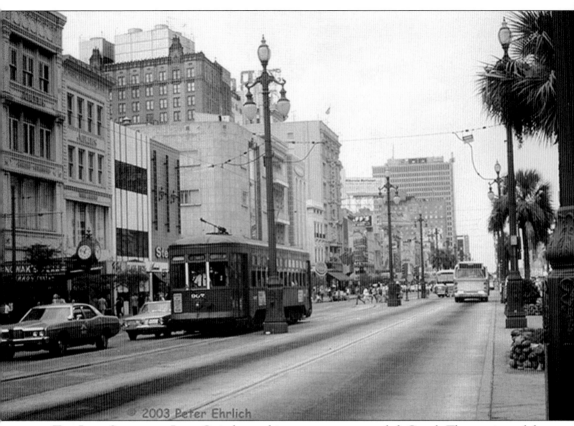

© 2003 Peter Ehrlich

**THE LAST STREETCAR LINE.** Strictly speaking, streetcars never left Canal. The portion of the outside riverbound track between Carondelet Street and St. Charles Avenue has always been active because this is where the St. Charles line turns around to head uptown. When the line gets to Lee Circle, the inbound cars go over to Carondelet Street because it's one-way inbound, and St. Charles is one-way outbound. In this 1978 Peter Ehrlich photo, Perley Thomas car 907 has turned onto Canal and is heading riverbound to the turn onto St. Charles. Two "new looks" buses are in the "zone" just up the street. (Courtesy Peter Ehrlich.)

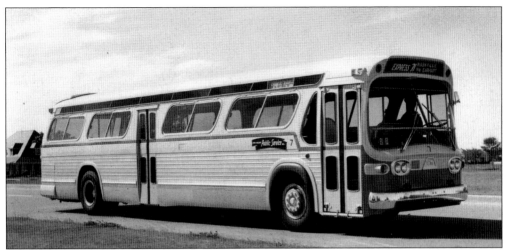

**"NEW LOOKS."** These GM buses began service in New Orleans in 1960 and ran well into the 1980s. In addition to the convenience of express service to Lakeview, bus service brought one other attractive item to Canal Street—air conditioning. Riding the streetcar down scenic St. Charles was one thing; sweating as you made your way to connections to Metairie or Lakeview at the cemeteries was something else entirely. (Courtesy New Orleans Public Library.)

**CHANGING SKYLINE.** Buses weren't the only thing changing downtown. A number of hi-rise buildings were constructed in the 1960s. The Bank of New Orleans (BNO) building can be seen in the background of this shot from Chartres Street. A "new looks" bus is heading riverbound. The running board says "BUS GARAGE," so he could either be preparing to turn onto Magazine and head back to Arabella Station, or will loop around and return to Canal Station. (Courtesy New Orleans Public Library.)

**CHANGING RIVERFRONT.** The empty space between Eads Plaza and Liberty Place was developed into the International Trade Mart building. This 1964 view from the river shows the building under construction. Below, the Rivergate Convention Center became the city's premier convention facility. By the late 1960s, New Orleans was taking the tourism and convention industry seriously, to the extent that even a Carnival organization was formed so businessmen who had to get back to work could see a parade Sunday night before flying home. (Courtesy New Orleans Public Library.)

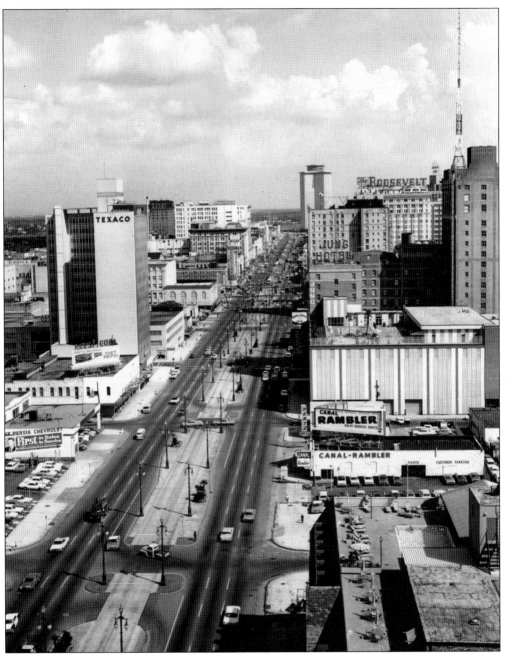

THE "NEW" CANAL STREET. Looking down from Claiborne Avenue to the river, this 1967 photo shows the many changes the 1960s brought to the street. The green Texaco building on the left housed that company's local operations until they moved into a building on Poydras Street in the 1980s. The Jung and Roosevelt Hotels no longer dominate the downtown side of the street, since the International Trade Mart building now looms in the background. The ITM building was renamed "World Trade Center" in the 1980s. Plans are in progress to convert the building into a hotel in the near future. (Courtesy New Orleans Public Library.)

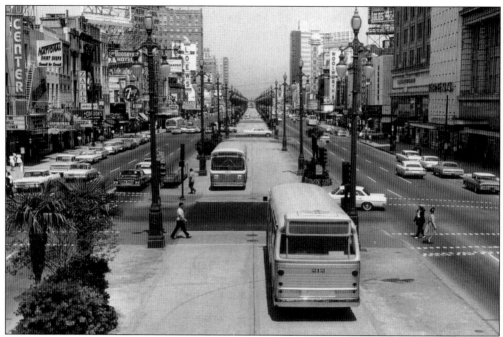

THE BUS ZONE. Above, two "new looks" buses pass each other in the neutral ground. These buses could be from any of the three Canal lines (Cemeteries, Lake Vista, or Lakeshore), or the two express lines that ran during peak hours. Below, Wreathed light poles bracket two buses they pass each other near Carondelet. Christmas on Canal Street was still a big event, with parents taking the kids to see Mr. Bingle and Santa Claus. (Courtesy New Orleans Public Library.)

CHRISTMAS WITHOUT STREETCARS. Wreathed light poles bracket two buses as they pass each other near Carondelet. Christmas on Canal Street was still a big event, with parents taking the kids to see Mr. Bingle and Santa Claus. The trolley wires for the Canal line have been cut down; the remaining wires visible are for trolley bus operations. (Courtesy New Orleans Public Library.)

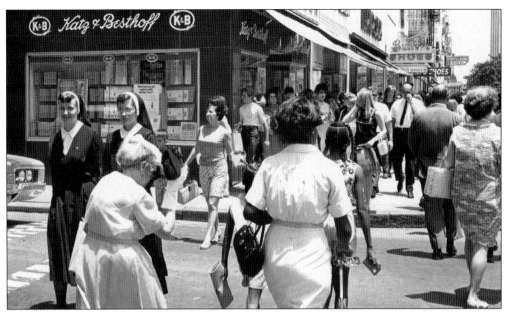

SATURDAY SHOPPING. Canal Street remained the premier shopping district of the city well into the 1970s. Lakeside Mall in Metairie opened in 1967, followed in 1972 by Clearview Mall, then The Plaza in Lake Forest (eastern New Orleans) in 1976. In the 1960s, however, shoppers still made their way between Holmes and Maison Blanche. (Courtesy New Orleans Public Library)

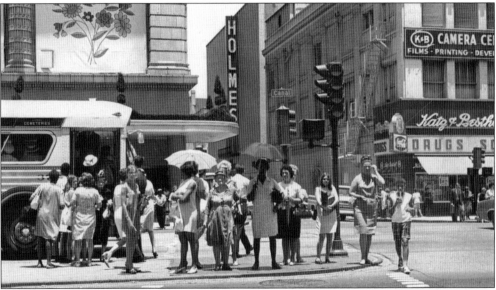

SUMMERTIME. Not a drop of rain, but umbrellas out means that it's summertime in New Orleans. Shoppers shielding themselves from the heat and humidity wait to cross Canal at Baronne. At the left, a Canal-Cemeteries bus is boarding passengers for the last few blocks of its riverbound run. Most of these passengers are boarding here to transfer to one of the many lines that terminate on Canal Street. Maison Blanche can be seen on the left, and the back of the D.H. Holmes store can be seen on the other side of Dauphine Street. (Courtesy New Orleans Public Library.)

THE WORLD'S FAIR. By the mid 1970s, New Orleans was losing shipping business to other cities along the Gulf of Mexico. Houston, Gulfport, and Mobile were attracting ships, leaving many of the city-owned wharves along the river empty, almost abandoned. A plan to re-vitalize the riverfront as a tourist development became the 1984 Louisiana World Exhibition. The artist's conception above shows the plan for the fair site, which ran from the Mississippi River Bridge, to the area near the Hilton Hotel at the foot of Poydras Street. The massive main hall for the Fair was to become a new convention center (which is now named after the late Ernest N. "Dutch" Morial, the first black mayor of New Orleans). The riverfront area from the main hall back to Poydras was planned to be exhibit area, and then was leased to the Rouse Corporation, who converted it into the shopping mall that is now the Riverwalk Marketplace. The LWE was a financial disaster, going bankrupt before the fair's six months ended, but the project totally revitalized the riverfront, prompting City Hall to begin promoting the development of a Riverfront streetcar line. (Courtesy of author's collection.)

**BROAD AND CANAL.** A&G Cafeterias were a long-time New Orleans fixture, with locations ranging from Metairie to the West Bank. The corner of North Broad Street and Canal has always been a busy transit intersection. The Broad line starts uptown, at Lowerline Street, and runs out as far as the NASA facility at Michoud Boulevard. (Courtesy New Orleans Public Library.)

**OUTSIDE THE CBD.** The tracks have been removed and trees and flowers planted on the neutral ground approaching Canal Station. A "new looks" bus pulls to the curb for a rider on the riverbound side. Modern light fixtures have replaced the trolley poles as part of the city's "Transit Improvement Program" for Canal. Warren Easton Senior High can be seen in the right-center background of this 1966 photo. (Courtesy New Orleans Public Library.)

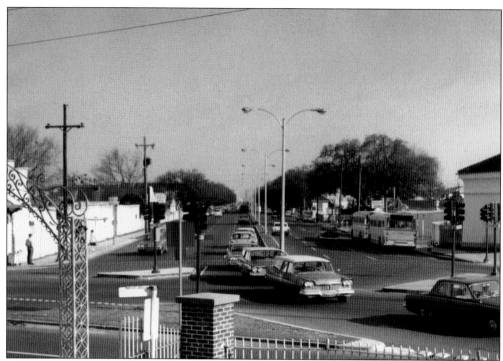

THE CEMETERIES. This is a view of the end of Canal Street from inside the Greenwood Cemetery fence. The neutral ground has been narrowed to almost nothing to create a turning lane for autos turning onto City Park Avenue, heading to West End or Metairie. Canal Buses queue up on the right, by the entrance to Cypress Grove cemetery, for their riverbound run. (Courtesy New Orleans Public Library.)

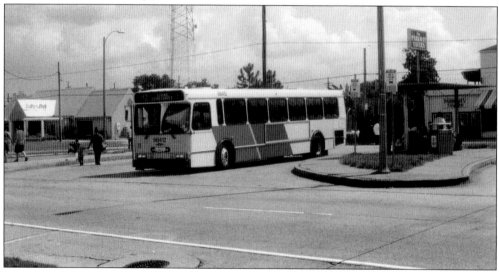

CEMETERIES BUS TERMINAL. Canal-Cemeteries buses, along with buses on the Esplanade line, terminate at the foot of Canal Boulevard, just across from Greenwood Cemetery. This bus bears the logo of the New Orleans Regional Transit Authority (referred to locally as the RTA). RTA was created in 1979 by the Louisiana Legislature, and RTA took over transit operations from NOPSI in the summer of 1983. (Courtesy the author's collection.)

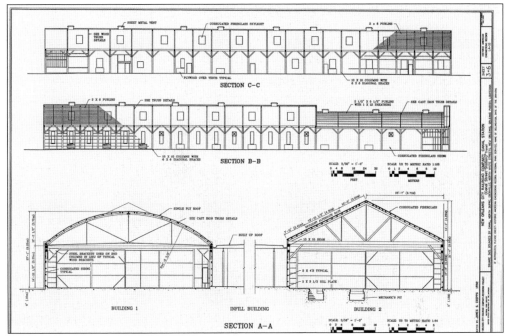

**CANAL STATION.** Converted fully to bus operation in 1964, Canal Station was one of NOPSI's primary facilities. Prior to its demolition, a Historic American Engineering Record (HAER) was created in 1992. The old barn buildings were torn down to make way for the more modern A. Phillip Randolph SIS (Service, Inspection, and Storage) facility. (Courtesy Library of Congress.)

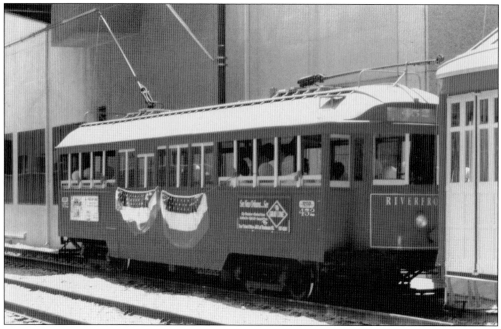

THE RIVERFRONT LINE. RTA's takeover of transit also included plans to expand streetcar operations. In 1988, the first new streetcar line since 1926 began to run in New Orleans. Initially a standard (railroad) gauge, single-track line with a passing siding, the Riverfront line operated with three 900-series Perley Thomas cars "brought home." The cars were painted a bright red, and the line was an instant hit. RTA operated two Melbourne W2 cars like the one above to accommodate disabled passengers. Ridership continued to grow, so RTA decided to completely re-do the line in 1997-98, converting it to wide (trolley) gauge and constructing seven new Perley Thomas-style cars like the one below. (Courtesy of the author's collection.)

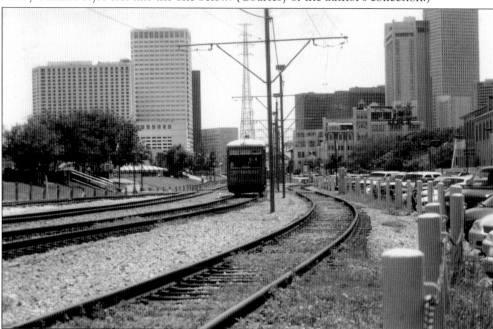

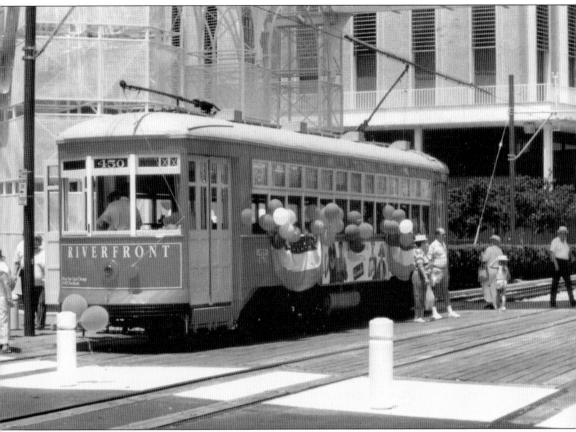

**RIVERFRONT OPENS.** The Riverfront line began operations in August of 1988. The grand opening marked the return of car 450 (ex-NOPSI 912) as the first car to roll down the line. The Riverfront line is not considered to be part of the "regular" RTA system; its fare is $1.50 one-way, and no transfers are available. In spite of this, tourists continue to flock to the Riverfront line as the best way to get from the Morial Convention Center to the French Quarter and back. The new Canal line offers "regular" service on the French Quarter section of the Riverfront line, so riders can board a Canal car at Esplanade, ride it into the CBD, and transfer to other lines there. (Courtesy of author's collection.)

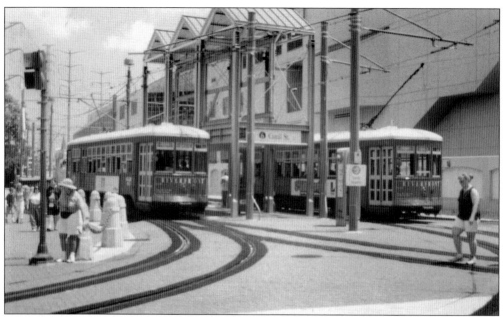

NEW TRACKS ON CANAL. As part of the 1997 overhaul of the Riverfront line, RTA constructed connecting trackage to link Riverfront with the St. Charles line via Canal Street. Prior to 1997, Riverfront cars were stored behind the Morial Convention Center (the western end of the line). With the conversion of the line to wide gauge, it was now possible to store (and easily service) the cars at Carrollton Station uptown. Above, cars 463 and 461 pass each other at the Riverfront line's Canal stop. Right, car 458 is in the barn at Carrollton Station. (Courtesy the author's collection.)

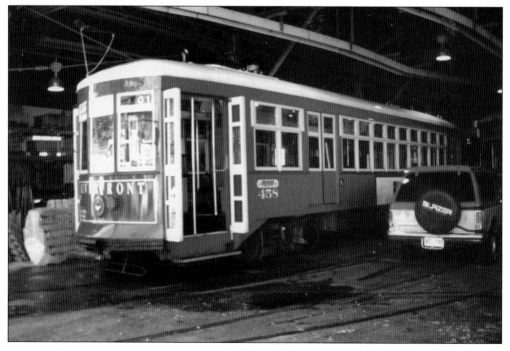

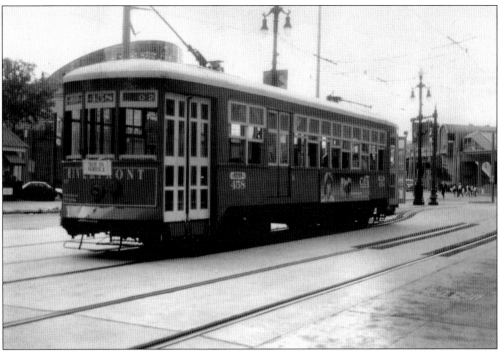

RIVERFRONT CARS. Car 457 was constructed in 1996 from the body of Riverfront 451 (ex-NOPSI 919). Car 458 (above) was built from scratch at Carrollton Station, using trucks and components from old PCC cars from Philadelphia. The rest of the Riverfront cars (459–463) were built with new trucks from Tatra in the Czech Republic. The 400-series cars maintain the overall look of the original Perley Thomas cars but with the addition of a center door/wheelchair lift, making them compliant with the Americans with Disabilities Act. The Riverfront cars currently operate out of Carrollton Station, coming down the St. Charles line from Willow Street, changing from the St. Charles track to the Canal tracks (left), then switching to their own line at the foot of Canal. (Courtesy the author's collection.)

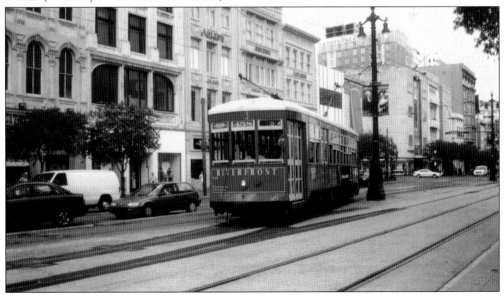

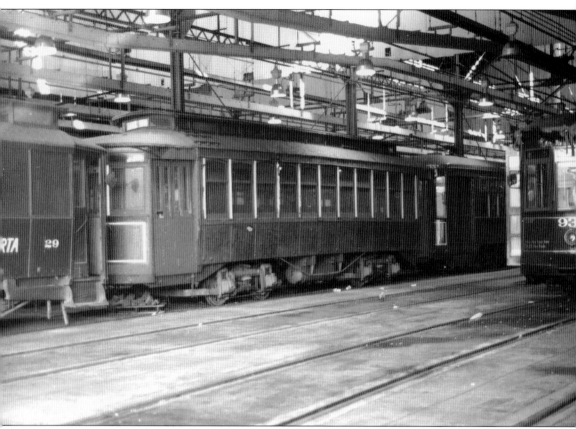

**THE TRAINING CAR.** The last Brill semi-convertible car in New Orleans is ex-NOPSI 453. Built by American Car Company of St. Louis (a Brill subsidiary), these cars were in service from 1906 to 1935. This car was retained in a training role until the 1960s, when its motors, compressor, and controls were removed, and it was loaned to the Louisiana State Museum. The museum put it on display at the French Market, next to the Old U.S. Mint. While on display, the running board on 453 showed "Desire," even though the Brills never ran on that line; to this day, many people, locals and tourists alike, associate this with *the* "Streetcar Named Desire." It was returned to NOPSI in the 1980s and now is stored at Carrollton Station. Car 453 is currently not operational, but RTA hopes to be able to find the funds to restore it in the future. (Courtesy the author's collection.)

# Six

# REBIRTH
## 2003–

*Since its inception in 1988, every step of the Riverfront streetcar line's development was an unqualified success. This emboldened RTA to return from a purely tourist-oriented street railway project to a full-blown light rail line on Canal Street. Plans were developed, input from the community solicited, and support from the city government acquired. Everyone was on board, so it was time for Carrollton Shops to develop a new streetcar.*

*Simply continuing the Riverfront streetcars would not do because they were not air-conditioned. This was one of the reasons the streetcars left Canal Street in the first place. Elmer Von Dullen and his team at Carrollton essentially started with a 400-series car: modified Perley Thomas body and CKD-Tatra trucks and propulsion (from the Czech Republic). The air conditioning unit and resistor packs for the controls had to go on the roof, which spoiled the styling of the classic Perley Thomas arch roof. To compensate, a mock monitor deck was constructed on the roof, hiding the appendages in the center of the roof. The prototype car of the 2000-series, 2001, has been running on Canal Street for over a year, operating from Baronne Street to the river. When car 2002 was completed, it also began operating on Canal Street, so that there has been one car running daily.*

*While there obviously is a lot of history involved in the return of streetcars to Canal Street, this line is not simply a "heritage" type of operation. The New Canal Line will operate from Esplanade Avenue and the river, stop number one on the Riverfront line, to the Cemeteries terminal. The line will branch off at North Carrollton Avenue, and a spur line will run from Canal to Beauregard Circle, in front of the New Orleans Museum of Art. The 2000-series cars are modern Light Rail Vehicles (LRVs) designed to have a long life and provide quality service to the French Quarter, Central Business District, and Mid-City neighborhoods.*

*All photos in this chapter are courtesy of the author's collection unless otherwise noted.*

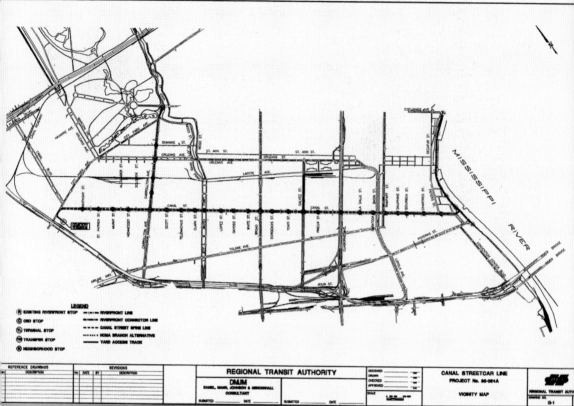

**THE ROUTE.** The route of the new Canal line begins at the Esplanade stop of the Riverfront line, at Esplanade and the French Market. The cars travel uptown from there to Canal Street, turning right onto Canal, then heading lakebound to the cemeteries. At Canal Street and City Park Avenue, the cars move onto a single-track terminus, change directions, then head back to downtown on the riverbound track. At the foot of Canal the cars turn left and head down the Riverfront line, along the edge of the French Quarter, returning to the double-track terminal at Esplanade. Additionally, some Canal cars turn right at North Carrollton Avenue to run on a spur line that goes down Carrollton to the Beauregard monument/traffic circle at Carrollton and Esplanade Avenues. This spur line services City Park and the New Orleans Museum of Art, as well as attracting tourists and locals alike to businesses and restaurants on Carrollton Avenue. (Courtesy RTA.)

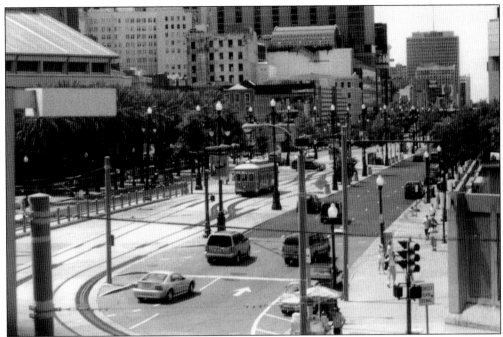

THE "NEW" FOOT OF CANAL. The Liberty Monument is long gone; in its place are two curves that connect the Canal trackage to the Riverfront line. Above, car 2002 waits on the center layover track. To the left is Harrah's Casino, which was constructed on the site of the old Rivergate Convention Center. Below, 2002 is going the wrong way on the lakebound track. The operator stopped the car shortly after the photo was shot, changed directions, and ran the right way on the lakebound track back to Baronne. These photos were shot from the elevated walkway of the ferry landing. The air conditioning unit and controller electronics can be seen inside the mock-monitor deck on the roof.

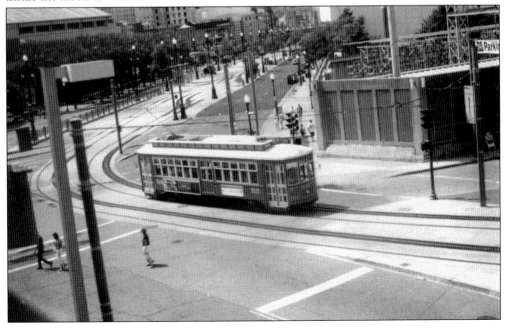

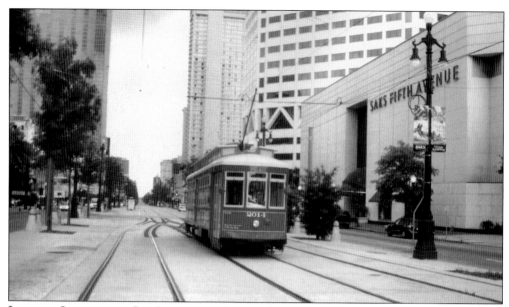

LOOKING LAKEBOUND. Car 2014 is on the middle track of the three-track layover in front of the Canal Place shopping mall. The car will switch back to the right-hand lakebound track when the operator is ready to move out. The Sheraton (left) and Marriott (right) hotels dominate the skyline to the point where the Maison Blanche building is barely visible in the far background.

LUCKY DOGS. During the spring and summer of 2003, no buses and only one streetcar operated in the Canal Street neutral ground. This enabled an unidentified Lucky Dog vendor (in his striped shirt) and his assistant to push one of the company's unique carts down the middle of the street, en route to the French Quarter. Lucky Dogs have been a fixture in the French Quarter and CBD since the 1950s.

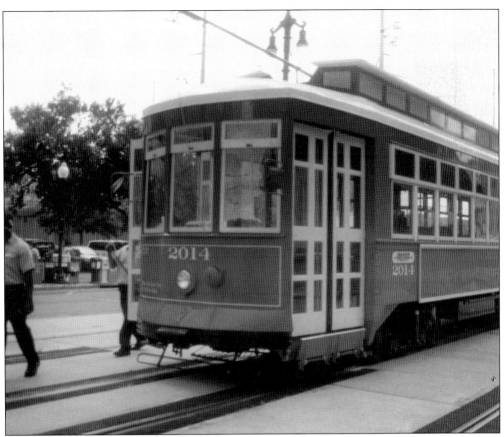

THE 2000-SERIES. The design of the new Canal cars is loosely based on the Perley Thomas arch roof design, but with a number of modern conveniences included. The ultra-modern Saminco propulsion control units and Brookville trucks make these cars so quiet that RTA has started an awareness campaign for motorists so they don't turn into one on the street because they didn't hear the streetcar coming! The interior of the 2000-series preserves the walk-around seats of the original Perley Thomas cars, maintaining a link with the past. The cars are air-conditioned, however, so the windows stay closed all the time. The cars have a center set of doors and wheelchair lift to accommodate disabled passengers (and comply with federal legal requirements). The wheelchair lift is designed to raise a passenger up from street level into the car, eliminating the need for raised platforms at stops.

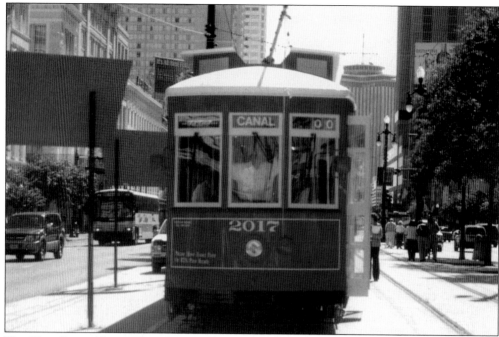

THE TEST RUN. Above, Elmer Von Dullen, superindent of the Carrollton Shops and the chief designer of the 2000-series, stands at the operator's station of car 2017 for the first full-route test run of the new Canal line, October 2, 2003. Just after 11 a.m., Von Dullen switched the running board on 2017 from 00 to 01 and headed the car lakebound. Taking their time, Von Dullen and a host of RTA employees walking along with the car made the trip down to the cemeteries terminal and back, experiencing no difficulties with any aspect of the line.

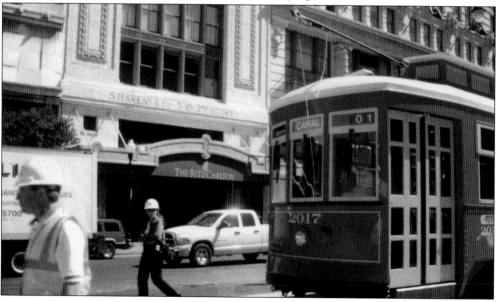

TRACK CONSTRUCTION. The roadbed for the Canal line is a far cry from laying down ties and hammering rails to them. This photo looks lakebound from Broad Street. The neutral ground was dug up and a concrete roadbed laid down. The rails were then embedded in concrete, and the whole thing covered up with topsoil and grass.

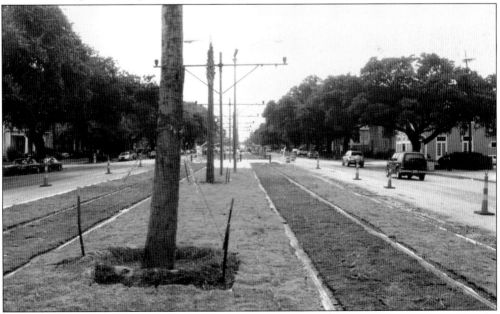

LANDSCAPED TRACK. This is the "after" view, looking from Salcedo Street riverbound. The exposed concrete has been covered, the grass planted, and the trolley wire strung. Palm trees like the one in the foreground were planted along the grass-covered portion of the route. All that's needed now is a streetcar!

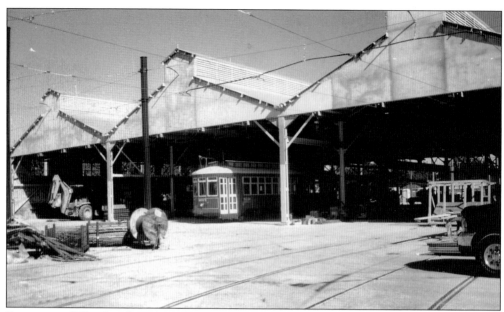

RANDOLPH SIS. Canal Station has been replaced by the A. Phillip Randolph Service, Inspection, and Storage (SIS) facility. A classic car barn has been constructed in the back lot of the bus facility, in the tradition and style of the old barn and Carrollton Station. Car 2013 was moved from Carrollton to Randolph in August 2003, so the complex maze of catenary wire could be tested. The SIS facility will be used to store and do routine maintenance on the 2000- and 400-series streetcars; those cars will return to Carrollton Shops when more extensive work is required.

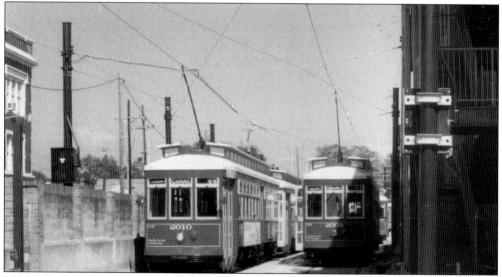

SIS ENTRANCE. Several cars are positioned on the entrance and exit tracks to the Randolph SIS facility. Streetcars enter on the right-hand track and curve around to the back of the barn (which is positioned perpendicular to the entrance trackage) and exit on the track closest to the wall. Behind the wall on the left is North Gayoso Street. Unlike Carrrollton Station, all the station trackage is on RTA property; the main reason for this is safety, since Warren Easton High School is next door.

**Sacred Heart.** One of the Catholic parishes for the Mid-City neighborhood, Sacred Heart Church also operated a small girl's high school until the 1990s. The school has since been converted to an assisted living community for the elderly. This is the second church on this site (Canal and South Lopez); the earlier church was torn down to make way for this building (see page 46 for a photo of the original church).

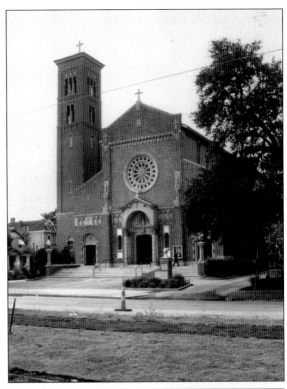

**Clearing the Track.** RTA workers lead car 2017 on the October 2, 2003 test run. The 2000-series cars only seat 40 passengers rather than the 52 of the 900-series, because seats had to be removed for the wheelchair lifts. The roof is still arched, even though it has the faux monitor deck on top.

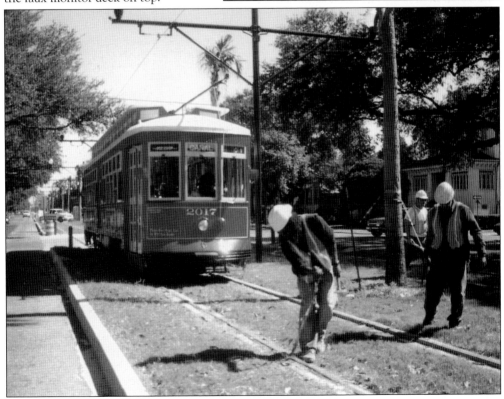

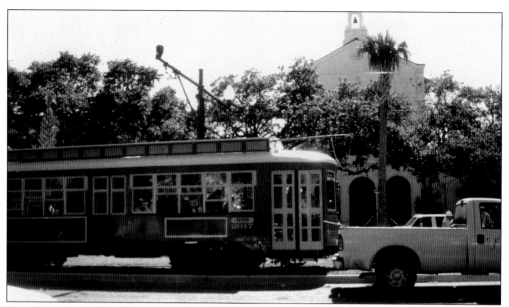

ST. ANTHONY'S. The first streetcar since 1964 passes St. Anthony of Padua church at South St. Patrick Street. This part of Canal Street from St. Patrick used to be the starting point for the Krewe of Mid-City parade, which ran all the way down Canal to St. Charles Avenue. The parade was switched to an uptown route during the construction of the Canal line. The Krewe of Endymion, the "super-krewe" that parades in town on the Saturday night before Mardi Gras, has also had to change its route from North Carrollton Avenue and Canal Street because of streetcar construction.

WARM WELCOME! Students from St. Anthony of Padua school greet the first streetcar to roll up Canal to the cemeteries in almost 40 years. The test run took longer than expected, so the school posted lookouts, and when the car was approaching, the kids came out with their signs. Elmer Von Dullen made a thorough test of the trolley bell in 2017 as the car passed by the excited group.

**APPROACHING THE TERMINAL.** Because the corner of Canal and City Park was extensively modified after the Canal line was discontinued in 1964 (see pages 73 and 104), the riverbound track at the terminal is actually in the left-hand auto lane for two blocks. The worker on the right side of the photo is actually standing in a traffic lane. The lakebound lane, however, is part of the neutral ground.

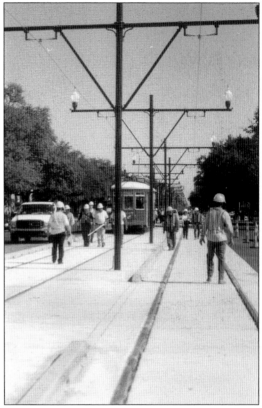

THE VIEW FROM GREENWOOD. Compare with photos on pages 73 and 104. Since the neutral ground here is so narrow, RTA planned to construct an off-street terminal where the streetcars could safely meet up with bus lines. Negotiations to acquire a lot in the 100 block of City Park Avenue (next to the old Halfway House) got complicated, so this on-street terminal was designed and built. RTA still hopes to build a larger terminal at some point in the future.

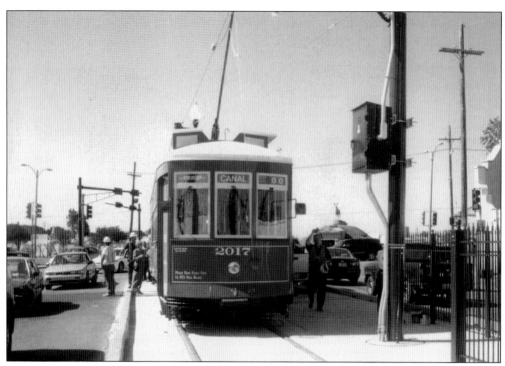

**RENEWING HISTORY.** Car 2017 pulls into the single-track stub terminal at Canal and City Park Avenue just before 3 p.m. on October 2, 2003, successfully completing a run up the street from downtown. In the background can be seen the Elks tumulus in Greenwood Cemetery. Workers checked the car and the terminal trackage, and the car itself, and all was in order. The car was pulled up to the fenced in pedestrian area of the terminal and the wheelchair lift tested. Canal Street was once again the location of a street railway.

**CEMETERIES TERMINAL.** The Fireman's Memorial in Greenwood cemetery can be seen in the background of this shot of the end-of-the-line terminal. The lakebound track goes straight into a single-track stub terminus. The operator then pulls down the trolley pole that was at the rear of the car for the lakebound run and releases the other pole to power the car for the trip downtown. After taking on passengers, the car then switches to the riverbound track on the left-hand side of the photo.

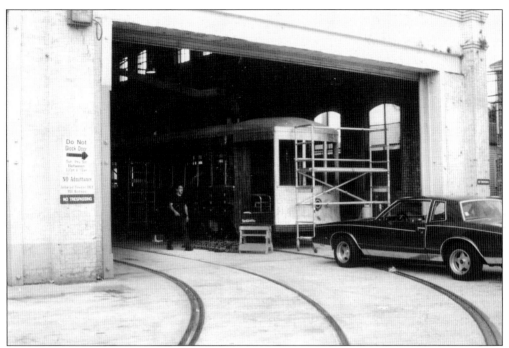

**2000-SERIES CONSTRUCTION.** The body of one of the 2000-series cars is being fabricated at Carrollton Shops. RTA did extensive renovations to the Carrollton facility in the mid-1990s, anticipating doing construction of the 400-series Riverfront and 2000-series Canal cars there.

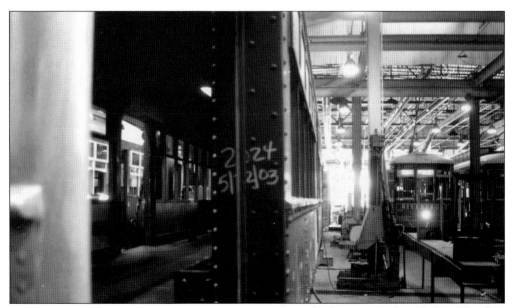

**CAR 2024.** The last of the production cars, 2024, is being built in September of 2003. The date on the body indicated the day that fabrication of the body was completed. One of the 400-series cars is in the background, in the shop for service.

# CANAL CAR

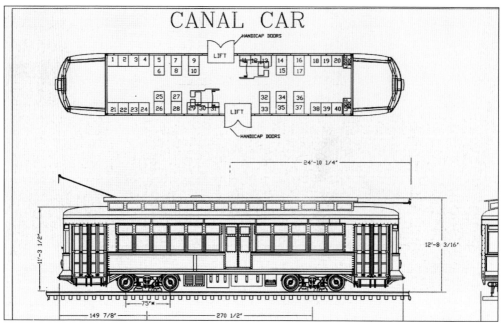

THE PLANS. These are the CAD blueprints of the prototype car 2001. The dimensions of the production series of cars (2002–2024) will be slightly different, since the prototype used CKD/Tatra trucks and the production cars have Brookville trucks. Note that the arch roof of the original Perley Thomas series has been retained; the mock monitor deck is strictly used as camouflage. (Courtesy RTA.)

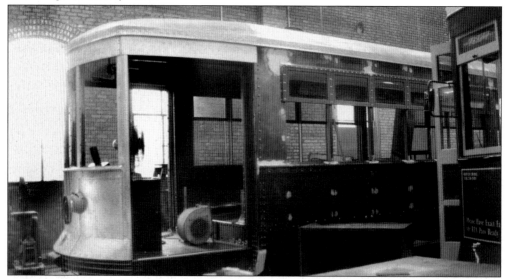

SCRATCH-BUILDING. The craftsmen of Carrollton Shops have been in the parts fabrication business now for some years. Since the original Perley Thomas cars of the St. Charles line are protected as landmarks, spare parts for them have to be scratch-built to the original specifications. This meant that Carrollton already had the skills to manufacture streetcars; they just needed the space. The body of car 2024 is under construction in the renovated shop building. Once it is completed and the trucks installed, it will be wheeled over to the paint shop track to get its coats of bright red paint.

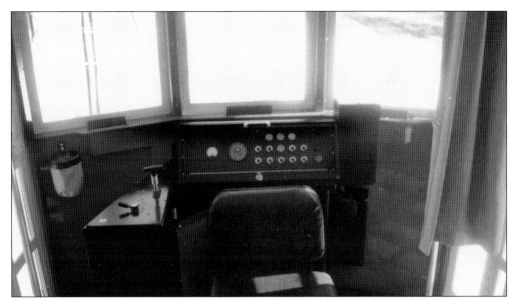

LRV CONTROLS. The new control panel of the 2000-series is that of a modern Light Rail Vehicle, a far cry from the old throttle and air brake handle of the 900-series. The curtain behind the operator's chair can be pulled across to block reflections in the window from passenger jewelry and/or clothing that might obstruct the operator's vision.

BROOKVILLE TRUCKS. The prototype car, 2001, used PCC-style trucks from the Czech Republic, similar to those used on the 400-series. RTA decided to use trucks and propulsion from the Brookville Equipment Company of Brookville, Pennsylvania. While Brookville had never built equipment for mass transit vehicles before, they have years of experience building rail vehicles for the mining industry.

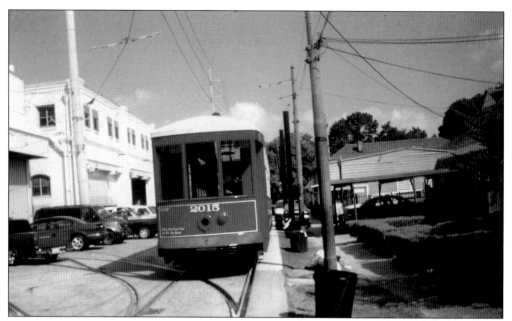

MOVING 2015. Car 2015 sits on Jeannette Street, behind Carrollton Station, in March 2003. The car's propulsion, trucks, and control systems have been installed, and it's been painted and lettered. It waits on the track behind the station so it can be moved onto a service track near the main barn and its electrical system can be completed. Once everything is in place, the monitor deck will be installed.

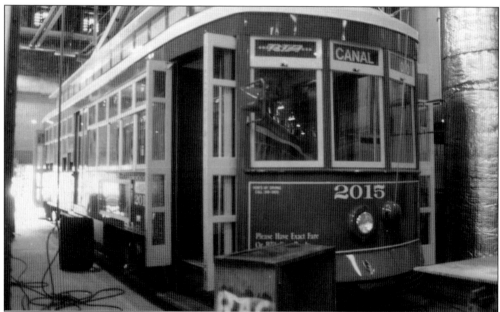

READY! Car 2015 is finished and ready to hit the street. The trolley poles and monitor deck are in place and the wheelchair lifts installed. The new cars were stored behind the Morial Convention Center (at the end of the Riverfront line) until the new barn was completed. They were then brought back to Carrollton to have the fare boxes installed, then moved over to the SIS facility on Canal.

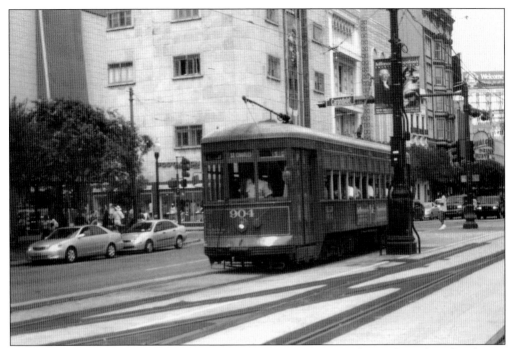

**STILL GOING.** The original Perley Thomas car 904 is on the outside riverbound track. The car has just turned onto Canal from Carondelet Street and will turn back to St. Charles. The switch connecting the riverbound Canal track with the outside St. Charles track is visible. Canal (and Riverfront) cars will use this switch to return back to Carrollton Station for repairs.

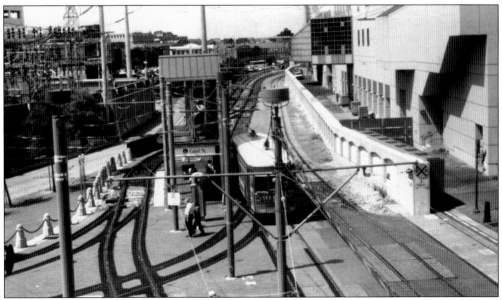

**ROLLING ON THE RIVER.** A 400-series car is headed down to Esplanade Avenue on the Riverfront line. The Canal tracks merge here with the Riverfront line. Riverbound Canal cars turn on the outside track (right-hand in the photo, behind this 400-series car), go to Esplanade, then cross over to the inside track and return upriver and up Canal to the cemeteries.

**THE IMPORTANCE OF PRESERVATION.** Ex-NOPSI 924, ex-RTA 450, this Perley Thomas car sits at the Carrollton Shops, waiting for restoration and a new purpose. One of original Perley Thomas 900-series, this car was sold off in 1964, then re-acquired in the 1980s for use on the Riverfront line. It was retired when the 400-series cars began operations on the Riverfront line. The long-range desire of the RTA crew is to restore 924 into a "party car" for the Canal line. It can't be used on St. Charles because it was restored with newer parts, and it can't be used for "revenue" runs on Canal because its design does not comply with the Americans with Disabilities Act. Streetcar preservations efforts in New Orleans have always been one-shot projects. From "Streetcars Desired" in the 1960s to "Bring Our Streetcars Home" in the 1980s, activists gathered when they had a project rather than developing an on-going organization to assist with preservation and restoration of our streetcars. It is the author's hope that this book and the website www.canalstreetcar.com will inspire streetcar enthusiasts to join him in forming a full-fledged street railway preservation society dedicated to assisting RTA in efforts to maintain the history and beauty of New Orleans's streetcars.